SHUFFLE AND DEAL

50 CLASSIC CARD GAMES

SHUFFLE *AND* DEAL

FOR ANY NUMBER OF PLAYERS

TARA GALLAGHER

HARPER DESIGN

An Imprint of HarperCollins Publishers

Shuffle and Deal

Design, layout and text copyright © Octopus Publishing Group 2015
Carmelite House
50 Victoria Embankment
London, EC4Y 0DZ

EXECUTIVE PUBLISHER: Roly Allen
SENIOR SPECIALIST EDITOR: Frank Gallaugher
SENIOR PROJECT EDITOR: Natalia Price-Cabrera
ASSISTANT EDITOR: Rachel Silverlight
COMMISSIONING EDITOR: Zara Larcombe
ART DIRECTOR: Julie Weir
IN-HOUSE DESIGNER: Kate Haynes
SENIOR PRODUCTION MANAGER: Katherine Hockley
DESIGNER: Prof. Phil Cleaver and *et al* design consultants ltd.

HarperCollins books may be purchased for educational, business,
or sales promotional use. For information please e-mail the
Special Markets Department at SPsales@harpercollins.com.

First published in the United States and Canada in 2015 by:
Harper Design
An Imprint of HarperCollins Publishers

195 Broadway
New York, NY 10007
Tel: (212) 207-7000
Fax: (855) 746-6023
www.hc.com
harperdesign@harpercollins.com

Distributed throughout the United States and Canada by:
HarperCollins Publishers
195 Broadway
New York, NY 10007

ISBN 978-0-06-238583-3
Library of Congress Control Number: 2013931917

Printed in China

First Printing, 2015

10 9 8 7 6 5 4 3 2 1

FRONT COVER: *Feine Bergmannskarte,* c. 1816, Industrie Comptoir
SPINE: *Tarot Microscopique,* c. 1870, Dondorf
BACK COVER: *Luxus-Spielkarte Vier-Erdteile,* c. 1880, Dondorf

CONTENTS

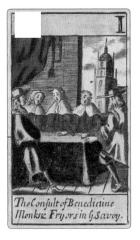

I

The Consult of Benedictine
Monks & Fryors in ye Savoy.

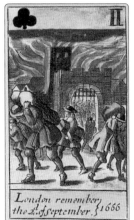

II

London remembers
the 2. of September. § 1666

III

Gifford and Stubbs giue mony
to a Maid to fyre her Masters house

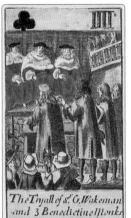

IIII

The Tryall of Sr G. Wakeman
and 3 Benedictine Monks

V

The Execution of ye 5
Iesuitts.

VI

Capt Berry and Alderman
Brookes are offerd 500 to cast
the Plott on the Protestants.

VII

Whitebread writeing letters
concerning ye state of Ireland

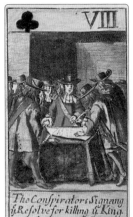

VIII

The Conspirators Signing
ye Resolve for killing ye King.

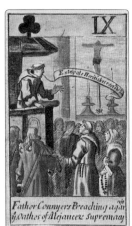

IX

Father Connyers Preaching agst
ye Oathes of Alegance & Supremacy

INTRODUCTION

Card games are the ultimate testament to human genius for making long hours fly by. People interacting with other people is what card games are all about, and the number of new ones that pop up year after year shows there's something enduringly appealing about beating the pants off your neighbor, boyfriend, or grandma.

Speaking of your grandma, the games featured in this book aren't her games, but that doesn't mean you can't play them with her—actually we're pretty sure she'll love them. All the games we've included have been picked because they're addictive, hilarious, and offer something a bit different from the old favorites.

Whether you're in a leaky tent halfway up a windy hillside or a villa in a fragrant orange grove, whether you're in a in a bar or a student dorm—we want you to whisper and yell, to cheat and get caught, to lose horribly and win the whole game, to weep with laughter, spill your drink, and make fantastic memories.

Playing cards originated in tenth-century China, but decks of cards similar to the ones we know didn't arrive in Europe until the fourteenth century. How they arrived in Europe is a bit of a mystery, but these days it's widely accepted that they arrived from the Egyptian Mamluk empire via Mediterranean traders.

In these early days cards were a luxury commodity, because, prior to Johannes Gutenberg's invention of the movable-type printer circa 1450, each set had to be painstakingly

OPPOSITE
For three years between 1678 and 1681, a fictitious Catholic plot to assassinate Charles II and seize power known as "The Popish Plot" gripped public imagination in England and Scotland. In fact, the conspiracy was entirely concocted by Anglican chaplain Titus Oates, who was eventually convicted of perjury. During the hysteria, and as illustrated in the 1♣, Benedictine monks were suspected of involvement in the plot. The 2♣ shows how recent disasters such as the Fire of London were retrospectively blamed on Catholic arson.

painted or drawn by hand. This meant that the humble deck of cards actually represented a pretty expensive toy. However, as soon as decks of cards became affordable enough to be within the reach of ordinary people, the popularity of card games went through the roof, enough so that honest clergymen were soon found pounding the pulpits against the evils of decadent gaming.

The suits evolved along with the decks, too, and actually the Hearts, Spades, Diamonds, and Clubs that most people are familiar with are relatively late additions—a French innovation dated to the fifteenth century. The first suits seen in Europe flourished around the Mediterranean and were copied from the Cups, Swords, Coins, and Polo sticks of Islamic decks of cards. Over time many countries created their own suits, such as Germany's Heart, Bell, Leaf, and Acorn motifs that are still in use today.

Upper-class Victorian society had a thing for Whist, while twentieth-century suburban Bridge parties were popular with the cocktails-before-dinner set; different games have waxed and waned in popularity throughout the history of playing cards, depending on how compatible they were with contemporary lifestyle. For you, the twenty-first-century reader, we've come up with games that are group oriented, fast paced, and fun.

We've included some noisy, easy-to-grasp ones with big groups in mind, and tactical tanglers that should have you plotting against your nearest and dearest; games that suit groups of various sizes and games that have never been published in book form before. Now pick a page, grab your deck, and go have fun!

2+ PLAYERS

AVALANCHE

INVENTED BY
Kápolnás György
and Légrády Gábor
gabor.legrady@
gmail.com

Avalanche is an unusual but very fun option for two to six people that needs a minimum of two full decks, including six Jokers. If you have more people, add more packs of cards to make the game comfortable to play.

No. of players: 2–6 Difficulty: medium

GAME TIP
The number of Jokers
in a deck varies—if you
have two decks but are
missing some Jokers,
use an ID or loyalty
card, or get crafty and
make yourselves some
more out of paper
or cardboard.

AIM

Collect the most cards.

DEALING

Suits don't matter in this game; you'll be paying attention to numbers. The card order goes from 2 as the lowest card to Ace as the second-highest card, with the Joker as the highest card. Everyone is dealt ten cards, and the rest of the deck is placed face down on the table.

PLAY

To start the game, in the first round everyone picks one of two options:

• Snowfall: Taking a card from the top of the deck and adding it to your hand.
• Start an avalanche: Placing any number of cards with the same number/rank (e.g., two 5s, three Kings) face up.

Once an avalanche has started (remember, an avalanche means there are cards face up on the table), fittingly enough, it can't be easily halted. Players no longer have the option of playing a snowfall. They can:

- Grow the avalanche: Put down the same number of cards as the last person to play did, of equal or higher rank, or more cards of any rank (e.g., if they put down two 5s, you could put down two 5s, two cards higher than 5s, or three 2s).
- Stop the avalanche: If the last person to play put down at least two cards, put down the same number of cards but of lower rank.
- Let the avalanche fall: Put down fewer cards than the previous player, or, if the previous player played just a single card, play a card of lower rank.

Once an avalanche has been stopped or allowed to fall, the next person to play can either choose to play a snowfall or to start a new avalanche.

When the avalanche falls: The face-up avalanche cards are given to the player to the right of the one who let it fall, who then stores them face down. (Remember, the aim of the game is to have the most cards at the end!)

When the avalanche stops: The avalanche cards are taken out of the game and put to one side. If at the end of a round the player has no cards left in their hand, they should draw a new hand of ten cards from the top of the deck, or all the rest of the cards if there are fewer than ten left.

GAME OVER
Once the deck is empty, you can't play any more snowfalls— it's all avalanches from here on! If there isn't one already, the next person to play has to start one, and once they run out of cards they're out. This keeps on going until just one player left with cards— they add their cards to their stored pile of cards and resist the urge to look smug.

BASIC RUMMY

There are lots of different permutations of Rummy; this version will give you all of the basics so you'll be familiar with the other versions, such as Rummy 500, which is featured on page 16, and Gin, featured on page 41. Rummy can be played with as few as two players, or as many as six. Either a fixed number of deals are played, or the game is played to a target score. The number of deals or the target score needs to be agreed upon before beginning to play.

No. of players: 2–6 **Difficulty:** medium

AIM

Win each hand by getting rid of all of your cards.

DEALING

One standard deck of 52 cards is used. Cards rank from Ace, which is low, up to the King, which is high. It's best to set a number of rounds or a target score to aim for before starting play. If there are two people playing, both players get ten cards dealt face down; if there are three or four players, seven cards each; and if there are five or six, six cards each. After the cards are dealt, take one card from the deck and place it face up on the table—this will be the discard pile. Leave the rest of the deck face down beside it to form the stockpile.

PLAY

Rummy turns have three parts: the draw, the *melding* or *laying off*, and the discarding.

1. Draw: At the start of their turn, the player must take a card either from the discard pile, which is face up, or from the stockpile, which is face down, and add it to their hand.

2. Melding: This is when you take a combination of cards from your hand and lay them face up on the table. There are two kinds of combination: sets (or "groups"), and runs (or "sequences").

- A set is three or four cards of the same number, such as 3♦, 3♥, 3♠, etc.
- A run is three or more cards of the same suit in consecutive order, such as 2♥, 3♥, 4♥, 5♥, or 10♣, J♣, Q♣, etc.

3. Laying off: This means adding a card or cards from your hand to an already-played meld (see above). The laid-off card must form part of a valid meld. For example, if a meld consisting of the 10♣, J♣, and Q♣ is on the table, you could add a 9♣ or a K♣, making a new run. You can also join a run and a set, if the set is complete and the suits fit—for example, if the set of 2♣, 2♥, 2♦, and 2♠ had been played, and you had a 3♠ and a 4♠ in your hand, once you have the 5♠ you can lay off a new run of Spades to create a meld of 2♣, 2♥, 2♦, 2♠, 3♠, 4♠, and 5♠. Note that you can't break up a meld to sneak cards into the middle—e.g., in the example above you are not permitted to make a space next to the 2♠ to lay off an A♠.

4. Discarding: Each player ends their turn by taking one card from their hand and putting it face up on the discard pile. You can discard a card you picked up from the stockpile earlier in your turn if you don't want to keep it. Now the play moves to the next person.

NOTE
You can't put down more than one meld in a turn, and if you're laying off, there's no limit to the number of cards you can lay off at a time. Melding is an option; you don't need to meld just because you can—in fact, hanging on to a run or set for a couple of turns, or even a whole game, can have some interesting results, especially when it prevents other players from putting down their own cards!

If the stockpile runs out, take the top card from the discard pile and put it aside to become the new discard pile. Turn the rest of the old discard pile over, shuffle, and this becomes the new stockpile.

To win the hand, you need to try to be the first to play all your cards by melding, laying off, and discarding. When one of you has gotten rid of all your cards, the hand is over and the points need to be totaled up. Each player adds up the points of the cards remaining in their hand, and the combined total goes to the winner.

SCORING

The King, Queen, and Jack are worth ten points each, and number cards are worth their numerical value—e.g., 3s are worth three points. Aces are low in this game and worth one point each.

The final winner is the player who is first to reach the previously agreed target score or the highest score after a certain number of hands has been played.

Though the style of costume on this deck reflects that of the Stuart period, the backs of the cards show their 1900-era origins. This girl is wearing an ancient dress, flowers adorning her hair, but she is pictured in a way similar to that found in contemporary portrait photography.

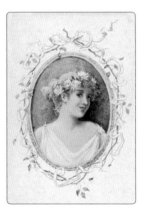

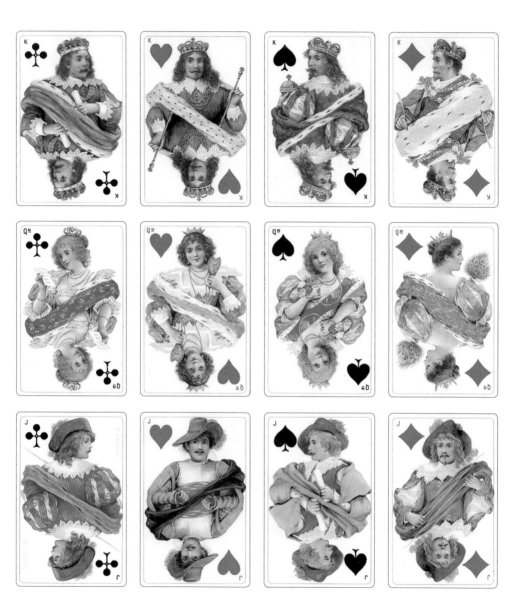

RUMMY 500

ALSO KNOWN AS
Persian Rummy,
500 Rum, or
Pinochle Rummy

Rummy 500 is similar to Basic Rummy (see page 12), but a more complex game requiring greater skill. To play, you'll need a standard 52-card deck plus two Jokers, so 54 cards. From two to eight people can play, but if five or more play use two decks to make 108 cards in total.

No. of players: 2–8 **Difficulty:** challenging

GAME TIP
Aces can be played high
or low, as you decide.

AIM

Win each hand by getting rid of all of your cards. Scores for each person playing are added up at the end of each hand until a value of 500 is reached. The first person to hit 500 points is the winner.

DEALING

Deal the cards one at a time going clockwise, starting with the person to the dealer's left. If just two are playing, they should receive thirteen cards each, and if there are three or more players, each should have seven cards. After the cards are dealt, take one card from the deck and place it face up on the table—this will be the discard pile. Leave the rest of the deck face down beside it to form the stockpile.

PLAY

Start the game with the player on the left of the dealer and continue playing to the left throughout the game. Rummy 500 turns, like basic Rummy turns, have three parts: *drawing, melding* or *laying off*, and *discarding*.

1. Drawing: At the start of the turn, take a card from either the discard pile (which is face up) or the stockpile (which is face down) and add it to your hand. You can take any card in the discard pile, but in this case you must
 - also take all the cards above it;
 - instantly meld the card you picked up in a new meld or lay it off—i.e., add it to an existing meld.

2. Melding: Melding is taking a combination of cards from your hand and laying them face up on the table. There are two kinds of combinations: sets and runs.
 - A set is three or four cards of the same number, such as 3♦, 3♥, 3♠, etc. When you're using more than one deck, the suits of a set must all be different, e.g., 3♠, 3♠, and 3♥ is not a valid set.
 - A run is three or more cards of the same suit in consecutive order, such as 2♥, 3♥, 4♥, and 5♥, or 10♣, J♣, and Q♣.

When laying off a card on someone else's meld, place the card in front of you, rather than alongside the existing meld—this makes it simple to total up everyone's scores at the end of the game.

3. Laying off: This means adding a card or cards from your hand to an already-played meld. When you lay off, you need to make another meld—that is, you need to make another run or set. For example, if the 10♣, J♣, and Q♣ are on the table, you could add a 9♣ or a K♣, making a new run. You can also join a run and a set if the set is complete and the suits fit—e.g., if the set of 2♣, 2♥, 2♦, and 2♠ had been played, and you had a 3♠ and a 4♠ in your hand, once you have the 5♠ you can lay off a new run of Spades to create a meld of 2♣, 2♥, 2♦, 2♠, 3♠, 4♠, and 5♠.

NOTE
You can't break up a meld to sneak cards into the middle—e.g., in the example here, you are not permitted to make a space next to the 2♠ to lay off an A♦.

As in Basic Rummy, you can't put down more than one meld in a turn, and if you're laying off, there's no limit to the amount of cards you can lay off at a time. Melding is an option; you don't need to meld just because you can.

Jokers are wild, meaning they can substitute for any card in a meld, even a duplicate of a card that has already been melded by you or another player. When you lay off a Joker, you must make it clear which card it represents—and no sneaky changing of what it stands for! For example, in a meld of 3♣, 4♣, and Joker as a sequence, the Joker represents the 5♣. Another player can play a 2♣ or 6♣ on this sequence, but they can't change the Joker to a 7♣ to get rid of an 8♣.

When melding one card and two Jokers you need to specify whether you're creating a run or a set, and if you're creating a run, you need to specify what the sequence is—e.g., if the Joker is representing the 9, is it 7, 8, 9 or 8, 9, 10? If you're creating a set with a Joker, you don't need to specify the suits represented by the Jokers as anyone can then lay off a different 9, completing a group of four 9s.

Learning how to draw from the discard pile in Rummy 500 can be tricky. Here's an example to help you get the hang of it:

Imagine that the discard pile has a K♥, 2♣, 8♥, 3♦, and 10♣ in it, with the uppermost card being the 4♥, and you want to get a hold of the 3♦ in order to complete a set of three 3s. You would take 3♦, 10♣, and 4♥. The 3♦ completes your set and you put your set down as a meld. You keep the 10♣ and 4♥. If you then discard the 10♣ when you complete your turn, the new discard pile is K♥, 2♣, 8♥, with the card face up on the top now 10♣.

When there are no cards left in the stockpile when someone wants to draw from it, or someone gets rid of all their cards, thus winning the hand, the turn is over. Everyone totals up the points for the cards they have melded, subtract-

ing the value of the cards they have left in their hands. If the cards left in your hand add up to more than the cards you have melded, your score for that hand is negative. Each player's end-of-round result is added to their score, which will continue at the end of each hand until someone hits 500 and is thus declared the winner.

SCORING

The King, Queen, and Jack are worth ten points each; number cards are worth their numerical value—e.g., 3 is worth three points; Aces and Jokers are worth fifteen points each.

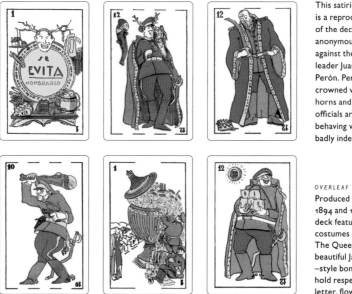

This satirical deck is a reproduction of the deck created anonymously in protest against the military leader Juan Domingo Perón. Perón himself is crowned with cuckold's horns and his military officials are shown behaving very badly indeed.

OVERLEAF
Produced between 1894 and 1933, this deck features Regency costumes circa 1800. The Queens wear beautiful Jane Austen –style bonnets, and hold respectively a fan, letter, flower, and bird.

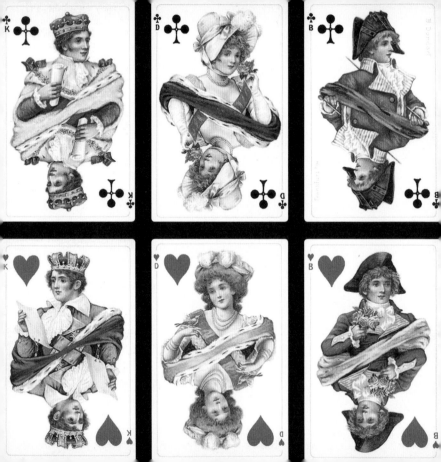

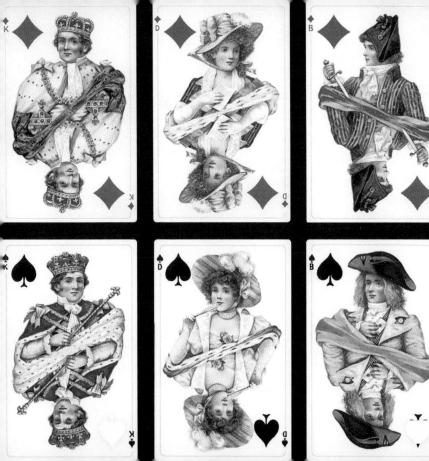

GO FISH

Go Fish can be played by as few as two players or as many as ten, but it's best enjoyed by three to six people.

No. of players: 2–10 **Difficulty:** easy

AIM

Collect more sets of cards with the same rank (e.g., 7s, or 5s) than your fellow players.

DEALING

A standard 52-card deck should be used. If playing with two people, deal seven cards to each person. If playing with three to six people, deal five cards to each person. Place the leftover cards in a pile face down—this pile is for players to draw from.

PLAY

Pick a player at random to start, and play to the left. To start a turn, pick the rank of a card in your hand, for example a 4, and ask one of the players for their 4s. The player must hand them over. If you received cards the last time you asked, you can take another turn and ask anyone else for another card of the same rank as the one in your hand. If the player doesn't have any cards, they respond "*go fish!*"

If you get a go fish, you can draw a card from the top of the pile and add it to your hand. In the eventuality that you'd asked for a certain rank of card, got a go fish, and then picked up a 3 from the stockpile, hold it up so the other players can

see, and then take another turn. If you draw another card, your turn is over, and the next player takes their turn.

You should aim to collect sets of four cards with the same rank, e.g., four 5s or Kings, etc.—this is referred to as a *book*. When you have a book, show the other players and put it face down in front of you. The play continues until a player has used all of their cards, or the stockpile has been used up. Whoever collects the most sets of cards wins the game.

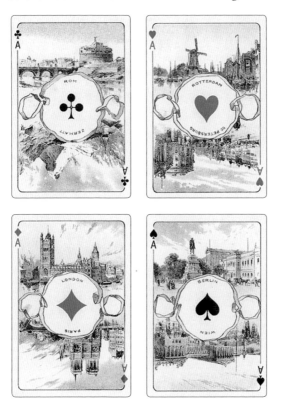

Each ace of this graceful 1910 deck shows scenes from two European capital cities. The Ace of Hearts shows Rotterdam and St. Petersburg, the Ace of Clubs shows Rome and Zermatt, the Ace of Spades shows Berlin and Wein, and the Ace of Diamonds shows London and Paris. Each city shows a famous monument— London shows the Houses of Parliament, and Paris shows Notre-Dame Cathedral.

CRAZY EIGHTS

ALSO KNOWN AS
Crates, Switch,
Swedish Rummy,
Last One,
or Rockaway

Crazy Eights is a game played across the world with varying names to match: its German name is *Mau-Mau*; its Swiss name is *Tschausepp* or Bye Joe; in the Netherlands it is *Pesten*, meaning bully or antagonize. You'll need two to seven people to play, with a standard 52-card deck for up to four players, or two decks shuffled together for more than four players. Aces are low.

No. of players: 2–7 Difficulty: easy

AIM

Get rid of the cards in your hand onto a discard pile by matching the number or suit of the previous discard.

DEALING

Five cards (seven if playing with just two people) are dealt to each player, one by one. The rest of the deck is placed face down to become the stockpile, and the top card turned over and placed beside the stock to become the discard pile.

PLAY

To play, each person in turn must place a *legal* card face up on top of the discard pile, or else take a card from the stock-pile. If you can't put down a card or don't wish to, you may pass. Legal plays are as follows:

- If the top card is any card but an 8, you can put down any card that is of the same suit or rank—e.g., if the top card is a 3♣, you could play any Club or any 3.
- 8s are special cards, and can be played on anything. When playing an 8, the player may nominate a suit.
- If the top card is an 8, then the only cards that can be placed on it are another 8 or any card of the suit nominated by the person who played the 8.

The winner is the first player who gets rid of all their cards—the other players score penalty points according to the cards they have left in their hands.

If everybody during a round of the game passes, the game is stopped, and everyone scores the cards remaining in their hands. If no cards are left in the stockpile, the cards that have already been played, except for the last card, are shuffled and placed face down to form a new stockpile.

SCORING
Cards left in players' hands at the end of the game are scored as follows:

- 8s: minus fifty points
- Aces: one point
- Face cards: ten points
- Number cards: face value

OLD MAID

Old Maid is a firm favorite among card players of all ages and is known by many names across the world, including *Le Pouilleux* (the one with lice) and *Orvieux Garçon* (confirmed bachelor) in France. To play Old Maid, you'll need two to eight players and a 52-card deck.

No. of players: 2–8 Difficulty: easy

AIM

Don't get stuck with the old maid.

DEALING

Before play starts, take three of the Queens from the deck and lay them to the side, leaving one Queen—this is your *old maid*. Working clockwise, the dealer deals card by card to however many people are playing until the entire pack is gone. All players should look at their hands and put face down on the table any pairs they have.

PLAY

The player sitting to the left of the dealer should offer their cards to the player on their left, who will pick a card without looking and put it into their own hand. Every time someone gets a pair, they must put it face down on the table. Play keeps going until all the pairs are in the middle and one person is left with the old maid and loses.

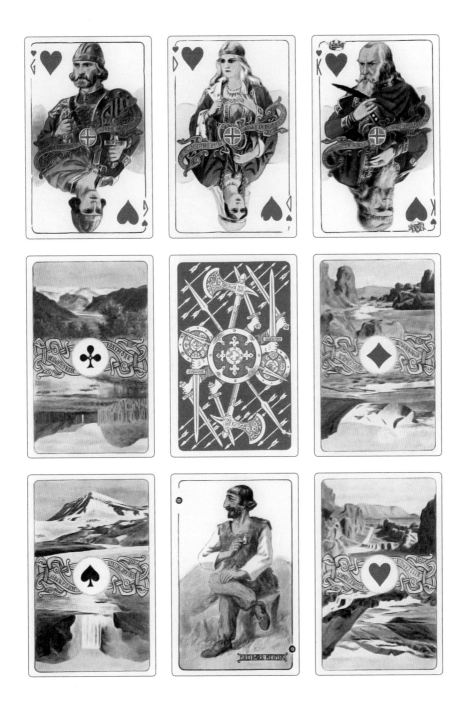

BLACKJACK

ALSO KNOWN AS
Twenty-one
or Pontoon

This casino classic can be played at home, is a great and relatively simple game for two or more people, and has the added advantage of making you feel a little bit like James Bond. Though many players can play in a single round of Blackjack, it's fundamentally a two-player game, with each player only playing against the dealer, not each other.

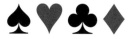

No. of players: 2+ Difficulty: medium

AIM

Get a higher point score in your hand of cards than the dealer has in theirs without going over 21.

DEALING

Take turns at being the dealer to make sure the game is fairly played. Use a standard 52-card deck, shuffled after each hand.

PLAY

Cards are worth different points, with 2 to 10 being worth the same as their numbers, while the face cards are worth ten points each. Aces can be worth either one or eleven points depending on what the player chooses at the time.

Blackjack is great fun as a betting game, but you don't necessarily need to play for money; matchsticks, rice, and paperclips all make good treasures. If you do play for money, set a minimum and a maximum bet for the game, and each player decides how much to bet on a hand before the deal.

If you . . .

• Win, then you get as much as you bet. If you bet two dollars, you win two dollars from the dealer and keep your original bet.
• Lose, then your bet will be taken by the dealer.
• Push, then it's a draw. You keep your bet, don't win anything, but don't lose anything either.

At the beginning of the round, the players and the dealer receive two cards. The players' cards are dealt face up, while the dealer has one face down (called the *hole* card) and one face up.

As you're trying to get close to 21 without going over, the best hand you could have is an Ace (which you could use as eleven or one, but in this case would use as eleven) with another card worth ten points, and you would automatically win unless the dealer also has 21, or *blackjack*. If the dealer has blackjack, all players without blackjack lose.

At the opening of your turn, you can either *stand* (keep your cards as they are) or *hit* (ask for more cards from the deck which are dealt out one at a time), until either you decide to try your hand against the dealer's hand, or until it goes over 21, in which case you lose (or *go bust*).

When all players have taken their turn, the dealer turns over his face-down hole card. If the dealer hasn't been lucky enough to have 21, he hits (adds more cards to his hand) or stands. The dealer is constrained by rules in a way the rest of the players aren't: the dealer must hit if their hand is lower than 17, and if not, they must stand.

When the dealer goes bust, all players still standing win, or those with higher point totals than the dealer win, and those with lower totals than the dealer lose.

SPIT

Spit is a fun, fast game for two people. If you've ever played Solitaire, then you'll find the card setup of Spit familiar, but this game is much rowdier! You'll need a standard 52-card deck with the Jokers removed to play. Aces can be low or high as you decide.

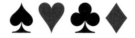

No. of players: 2 **Difficulty:** easy

AIM

Get rid of your cards as fast possible.

DEALING

Split the deck roughly between each player. Each player shuffles their half and then deals themselves out five stock-piles in the following format:

- Stockpile #1: one card face up
- Stockpile #2: one card face down, one card on top face up
- Stockpile #3: two cards face down, one card on top face up
- Stockpile #4: three cards face down, one card on top face up
- Stockpile #5: four cards face down, one card on top face up

Once these are dealt out, each player puts the remainder of their cards in a pile on the table to draw from during the game—these are the *spit* cards.

PLAY

When you're ready to play—at the same time, both players should turn over a card from their spit pile, while shouting "spit!" Whatever the value of the card turned over, a player can take one of their face-up stockpile cards that's lower or higher than the card value and put it on the spit pile, e.g., if the spit pile turns over a 3, they can put down a 2 or a 4. It's a race to put your cards down on the spit piles, and you can put your cards down on either pile as long as the numbers work—so be fast!

You should always aim to keep five stockpiles in front of you; if you have a space, take one of the cards from your face-up piles and move it to the space. Then turn over the face-down card on the stockpile you moved the card from. Once you start running out of cards, having fewer than five stockpiles can't be avoided, but early in the game turn over everything you can.

Each turn naturally ends when neither player can put down any more cards—then both players again turn over a card from their spit pile at the same time, and shout "spit!"

Once one player puts down their last card, both players need to grab for the smallest-looking spit pile. The players add any spit and stockpile cards remaining on their side to the spit pile they took, shuffle their cards well, and deal again as before—at this point one of the players will have a smaller hand than the other.

Each player should score one point for each card they have remaining at the end of each round. The loser of the game will be the first one to hit 100 points, and the player who has the lowest score is the winner.

EGYPTIAN RATSCREW

ALSO KNOWN AS
Egyptian Ratscur,
Egyptian Ratscurry,
Egyptian Ratslap,
Egyptian Ratkiller,
Egyptian War,
or Slap

This fast-paced game is a bit like Spit (see page 30). To succeed, you'll need to think—and act—quickly. You'll also need a regular deck of cards (minus the Jokers).

No. of players: 2+ **Difficulty:** medium

THE SLAP RULE
When a player puts down a card of the same value as the one below it, any player can then *slap* the pile. The first person to slap the pile of cards when the *slap rule* is put into effect is the winner of that round. If it cannot be determined who was the first to slap the pile, the person with the most fingers on top wins. If the tie cannot be resolved this way, then play simply continues normally.

AIM

Take as many of the cards as possible.

DEALING

Deal the entire deck, face down, and so that everyone has the same amount. Players should not look at their cards.

PLAY

The first player takes the top card from their pile and places it face up in the middle of the table. If the card put down has a number on it, the next player puts down a card, too. This continues around the table with everyone putting down a card until a Jack, Queen, King, or Ace is played.

When one of these cards is played, the next person to play must put down another face card for the turn to keep going. The number of draws they get to try to do this depends on the initial letter that was picked—Aces: you get four attempts; Kings: three attempts; Queen: two attempts; Jack: one attempt. If they fail, the player who played the last face card wins the round. They get all of the cards in the pile and then get to start the next round. Play continues until one player has all the cards.

—32—

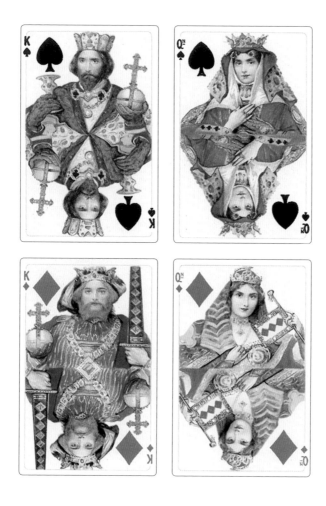

This is a special deck featuring characters from Shakespeare's works, published by Dondorf as "Shakespeare-Spielkarte." The paintings of the courts were by artist John H. Bacon, and each suit featured characters from various different plays. Spades are from *Hamlet*—K♠ is Claudius, Q♠ is Gertrude, and J♠ is the grave digger. Diamonds are from *Henry VIII*—K♦ is Henry VIII himself, with Q♦ as Katherine of Aragon and J♦ as Sir Thomas Lovell. The deck is continued on page 77.

SPADES

Two people can play Spades as individuals, or four people can play in two teams. We'll be explaining how to play with individual players. You'll need a standard pack of 52 cards, and Aces are played high.

No. of players: 2–4 Difficulty: challenging

GAME TIP #1
Everyone should look at their cards at the same time once they are dealt, so that nobody has an unfair advantage.

GAME TIP #2
Make sure to write down the bids so you all remember who bid how many tricks—it's easy to forget.

AIM

Players bid on *tricks*, or sequences of cards, to win.

DEALING

Deal the cards clockwise until everyone has thirteen cards.

PLAY

Before starting, the players must decide on the winning score that players have to aim to get to in order to win the game—try 200 for the first game and then adjust to whether you want a longer or shorter game.

Once they have picked up their cards, each player decides how many tricks, or rounds of the game, they think they will be able to win and bids that number. The minimum you can bid is one trick, and you can't decide to pass.

To start the round, one person puts down a card from their hand. The card they put can't be a Spade, as Spades are the *trump* suit (the suit that outranks all other suits). For example, if the first player puts down a 2♥, everyone else must put down a Heart if they can.

To win a trick, you need to have put down the highest value card of that trick—for example, the first player puts down a 2♥, the rest of the players put down in order a 5♥, a 3♥, and a 10♥. The player who put down the 10♥ wins the trick. When a player wins a trick, they take all the cards and put them face down, and record one trick.

If a player can't play a card of the same suit, they must either discard (put down a card of another suit) or trump (play a Spade). If a Spade is played, the highest Spade wins the trick, but if players discard other cards, the player who plays the highest card of the original suit wins. For example:

- In a trick that contains the 2♦, 7♦, 5♣, and K♥, the player who put down the 7♦ wins.
- In a trick that contains the 4♥, 6♠, 5♣, and K♠, the player who put down the K♠ wins.

Play until all thirteen tricks have been played—by this point, all cards should be gone from your hands, and it's time to total up the score.

SCORING

Count the total number of tricks (which should each be made up of four cards) you won. Then compare the number of tricks you won to the number of tricks you bid—if you bet four tricks, and you won at least four, multiply the number of wins by ten. If you bid three tricks, but only got two, multiply the number of tricks bid by minus ten.

SANDBAG POINTS
If you win over the number of bids, you receive an extra *sandbag* point for each trick you exceeded it by. If you get ten sandbag points, you suffer a 100-point penalty, so be careful about overbidding!

OVERLEAF
The colors in this luxury Dondorf deck are bright because they are chromolithographs, an old method of chemically printing color pictures from a series of stone or zinc plates. This process was not cheap, and it could take weeks for very skilled workers to produce such a detailed chromolithograph.

CUCUMBER

Cucumber is a fun, unusual trick-taking game for two to seven players. Play is with a standard 52-card deck, and Aces are high.

No. of players: 2–7 **Difficulty:** challenging

AIM

Be the last player standing at the end of the game—to do this, you need to avoid winning the last *trick* of the game, which comes with penalty points.

DEALING

The dealer should deal seven cards to each player. The rest of the deck should be set aside as it won't be used.

PLAY

Seven tricks are played in each round, and the winner of each trick starts out the following trick.

To begin, the first player puts down a card of their choice face up. The following players must take their turns one by one, putting down a card that is either the same rank or higher than the highest card that has been played so far, or the lowest-ranked card they have left in their hand.

The player that puts down the highest-ranking card wins the trick; however, if more than one of the highest-ranking cards has been played (e.g., there are two or more 8s in a trick where 8 is the highest card) the last one played wins.

The player who wins the seventh trick in the round loses the round and incurs penalty points depending on the rank of the card played (Ace: 14, King: 13, Queen: 12, Jack: 11, and the rest of the numbered cards' values correspond to their numbers). When a player's score hits 21, they receive a *cucumber*—that is, they lose a life. The dead player comes back to life in the next round, but with the same score as the highest score of any other player (check who has the highest score and whatever it is, the reincarnated player will have the same). When a player gets two cucumbers (i.e., hits 21 points with the second cucumber), they're out of the game.

Another tricky aspect is that if in the seventh trick any other players play a card of the same rank as the card that won, these players are awarded a bonus of the same size as the penalty points the loser suffers, which they need to deduct from their score. Bonuses can't bring a score down below zero or below a cucumber and a zero, and they are deducted only after the loser's score is added.

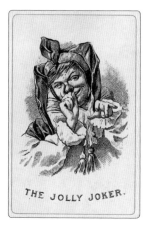

THE JOLLY JOKER.

Jokers were introduced to the modern deck around 1860, specifically for a game called Euchre. In fact, it was the German spelling, *Jucker,* that gave the card its name!

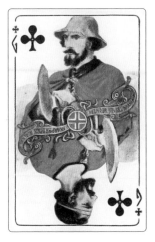
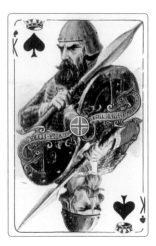
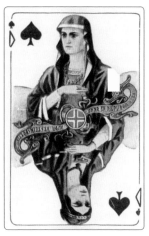
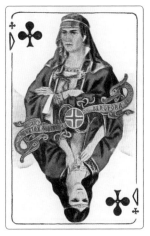
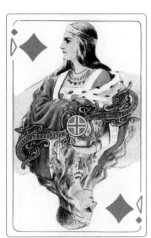
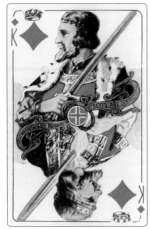
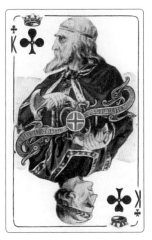
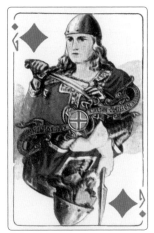
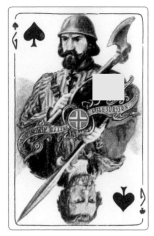

GIN

This is a two-player form of Rummy invented in 1909 by Whist teacher Elwood T. Baker and his screenwriter son C. Graham Baker. It is played with a standard 52-card pack, and Aces are low.

ALSO KNOWN AS
Gin Rummy

No. of players: 2 **Difficulty:** challenging

AIM

Collect a hand that is entirely composed of sets and runs. The winner is the first player to reach a score of 100 points.

GAME TIP
You'll need to keep score, so make sure you have writing materials handy.

DEALING

Ten cards should be dealt to each player, and the rest of the deck put into a stockpile between the players. The top card of the stockpile is turned over to become the first card of the discard pile.

OPPOSITE
Tryggvi Magnússon's Icelandic deck includes some fascinating figures: the king of diamonds was Njáll of Berhthórshváll, a tenth-century lawyer who, after his sons become involved in a dispute, was burned alive with them and the Queen of Diamonds (his wife, Bergthóra Skarphéðinsdóttir) in their home.

PLAY

The draw is special on the initial turn: the players pick up, look at, and sort their cards. The player who didn't deal goes first and can choose whether or not to draw the turned-up card. If that player doesn't draw the turned-up card, then the dealer can; and if neither player chooses to draw it, then the nondealer draws from the stockpile. They then put down one card from their hand onto the discard pile.

Knocking is a tactic that is central to Gin and ends the hand. After picking up a card and discarding as usual, a player that has a hand with some runs and/or sets (check

Basic Rummy on page 12 for what sets and runs are) and some cards that don't fit into these, or *deadwood* cards, can knock. Deadwood cards are scored as follows, and to knock your deadwood cards must total less than ten points. Jacks, Queens, and Kings are worth ten points, Aces are worth one, and normal number cards are worth the number they represent, e.g., a 3♣ is worth three points. You can knock on any turn, including your first turn.

To knock, the player shows their hand, puts down all sets and runs, and puts deadwood cards to the side to be scored.

Going Gin: This happens when a player is able to knock but doesn't have any deadwood cards. When a player goes gin, they get a special twenty-point bonus when scoring.

The next player may then lay out any melds in their hand and lay off any of their deadwood cards that fit into the knocking player's melds, unless the player that knocked had a gin hand, in which case the nonknocker can't lay off cards.

If there are only two cards left in the stockpile and the player who took the last card from the stockpile discards a card without knocking, the hand must be ended with no score counted.

At the end of the hand, total up the score. If a player had a gin hand, they get a twenty-point bonus plus the value of the other player's deadwood cards. If the knocker's point count in deadwood cards is lower than the other player's, the knocker scores the difference between the two totals of deadwood and is the winner. If the knocker's score is tied with the nonknocker's score, or is higher, the nonknocker has undercut the knocker, scores the difference, and gets a bonus of twenty-five points.

Play continues until one of the players hits 100 points and wins the game.

ALL FOURS

All Fours was first recorded in seventeenth-century England, though it really spread in popularity in the nineteenth century in the United States. This is a game for two players and can be adapted for four (how to play with four is explained on the following page). It should be played with a standard 52-card deck, with Aces played high.

ALSO KNOWN AS
High-Low-Jack
or Seven Up

No. of players: 2 or 4 Difficulty: challenging

AIM

Be the first to score seven points by winning the best cards in the six tricks or rounds.

TROPICAL TIP
All Fours is the
official national game
of Trinidad and Tobago,
and is particularly
popular across the
Caribbean.

DEALING

The dealer deals six cards out in lots of three to each player, and the next card is turned face up to decide the *trump* suit (the suit that outranks all other suits).

PLAY

The nondealer player says whether they will *stand* (accept the turned-over card as the trump suit and begin play) or *beg* (reject the trump suit). If a player begs, the dealer decides whether to refuse this (saying "take one" and gifting the other player one point) or accept (saying "I run the cards," dealing three more cards for both players, and turning over the next card to determine the new trump suit). If this is the same suit, the dealer runs the cards again until a new suit comes up. When cards have been run, three cards from each

FOR FOUR PLAYERS
Two players play in a partnership or team against two other players. The only real difference to the main game is that just the dealer and one of their opponents look at their cards to determine the trump suit and follow the stand or beg process as usual. Once this has been done, everyone looks at their cards and the game begins.

player's hands are discarded to take both hands back to six. Whenever the trump suit card is a Jack, the dealer scores a point.

Once the trump suit has been determined, the first player plays a card, and the next player may freely either *follow suit* (play a card of the same suit as that of the leading suit) or trump (play a card from the trump suit). The *trick* is won by the highest trump card played on it, and if no trumps are played the trick is won by the highest card of the suit led. For example, if the first player puts down an 8♥, and the next puts down a 10♥, then the 10♥ player wins the trick. When a player wins a trick, they take all the cards and put them face down near themselves. If a player can't play a card of the same suit or trump, they can put down a card of another suit. Play continues until all six tricks have been played, and then players total up the victories and award one point for each.

SCORING
Count in the order of High, Low, Jack, and Game to determine who has reached seven first to avoid ties.

High: won by the player who had the highest trump
Low: won by the player who held the lowest trump that was dealt. It doesn't matter who won the trick, the point goes to the original holders
Jack: taking the Jack of trumps
Game: having the tricks with the highest total points, calculated as follows:
- 10s: ten points
- Jacks: two points
- Queens: three points
- Kings: four points
- 2–9: no value

NINE-HOLE GOLF

This game is called Nine-Hole Golf because, as in golf, the lowest score wins. It's best for two to four players, but more can play—just note that if more players join, you may need an extra pack or two of cards. Two or three standard 52-card packs are required, including Jokers, so that each player has enough cards.

ALSO KNOWN AS
Crazy Nines or Nines

No. of players: 2+ Difficulty: easy

AIM
Get the lowest score.

DEALING
The dealer deals nine cards to each player, one at a time. Players arrange their cards face-down in a three-by-three square, and the remaining cards are placed face down in a pile in the center of the table.

PLAY
The top card is turned face up and placed next to the stack to start the discard pile. Each player can turn over any three of their cards, but does not look at the others until they add them to the discard pile when swapping them, or at the end of a round to total up the score.

When the cards are totaled up at the end of the game the lowest score wins, so players must try to get rid of their high-scoring cards, either by swapping them or by rendering them zero points (more on this shortly).

As their first move, the beginning player picks whether to draw the top card of the pile in the middle (face down) or take the top card in the discard pile (face up) to replace one of their nine cards. If they choose from the face-down pile and do not want to keep their card, they can add it to the top of the discard pile without swapping it for one of their nine. Any cards swapped out of the nine cards are placed face up on the discard pile.

Getting a triple: If at the start of the game you have, or throughout the game you get, two cards of the same rank, rearrange your nine so these two are next to each other, either horizontally or vertically. Then try to get another of the same card, swap it out for the last card face down next to your two of the same to make three of the same, and get a score of zero for all three.

SCORING

Card	Score	Card	Score
Ace	one point	King	zero points
2 to 10	face value	Joker	minus two points
Jack	ten points	Triples	zero points
Queen	ten points		

Once a player has all nine of his cards face up, the game is over, any remaining face-down cards are turned over, and scoring begins—the player with the highest score is the loser.

IPSO

Ipso is a betting game for two to five players. It's very much like a simple version of poker and a good introduction to that kind of betting game. It requires a standard 52-card pack with Aces low and Jokers removed.

INVENTED BY
Steve Bradbury
stebra90@yahoo.co.uk

No. of players: 2–5 Difficulty: challenging

AIM
Players must bet on who has the best four-card hand.

DEALING
The dealer deals everyone four cards, and places the remainder of the pack face down on the table where it becomes the face-down stockpile. The top card of this pile is turned over and becomes the face-up flip pile. As the match goes on and players discard cards, there will be a face-down discard pile and a face-up discard pile coming to a total of four piles, though to begin with the two discard piles are empty.

PLAY

There are eight possible hands, given below from highest to lowest:

1. Quad: four cards of the same rank
2. Prial & rider: three cards of the same rank the prial, plus one face card (King, Queen, or Jack) as the rider
3. Bouncer: four ascending cards of the same suit, e.g., 3♦, 4♦, 5♦, 6♦
4. Run: four ascending cards not of the same suit
5. Flush: four cards of the same suit, but not a bouncer
6. Pairso: two pairs of cards, e.g., Jack-Jack, 2-2
7. Pair & kickers: one pair of equally ranked cards and two other cards known as kickers
8. High card & tags: any card combination that doesn't fit in with any of the above. The tags are the cards other than the highest card.

A betting round involves one action by each player in turn, consisting of paying some money into the amount up for grabs, or folding. Six betting rounds are played in a game, unless it ends naturally before then:

1. Before the deal—to start things off, each player must put a fixed *ante* (amount agreed in advance) into the pot
2. After the deal
3. After first exchange
4. After second exchange
5. After third exchange
6. After fourth exchange

At the second betting round, the first player must either place a *stake* (needs to be at least the amount of the agreed minimum bet, if you've agreed minimum and maximum bets) or *fold*. If this player folds the next player has the same options, as do all other players. If everyone other than the dealer folds, the dealer receives the antes and the game ends.

After a player has placed a bet, the subsequent players can do one of three things, based on how confident they are of their hand being able to beat the rest, or of their ability to bluff:

• Cover: Add a stake to the pot equal to that added by the previous player.
• Cover and raise: Add a stake to the pot that is more than that added by the previous player.
• Fold: The player quits the game, their cards are put down face down, and any money already bet goes to the game's winner.

After the betting round comes the exchange. Here, each player can swap a card from their hand (putting it down face up in front of them) for the top card of any of the four piles detailed previously. If a face-down card is picked up, it is not shown to the other players, and the card being got rid of is placed on either the face-up discard pile if the new card was taken from a face-up pile, or face down on the face-down discard pile if the new card was taken from a face-down pile. If the new card was taken from the face-up flip pile, the top card of the face-down stockpile is turned over to start the new face-up flip pile.

Anyone that doesn't want to exchange a card can say "skip" and skip the exchange, keeping their hand as is.

OVERLEAF
Since playing cards became popular in the fourteenth century, many different types of deck have been used in Europe. The suits that most UK- and US-based people are used to playing with—Hearts, Diamonds, Clubs, and Spades—are actually French suits, which have become almost the default suit in the West. This beautifully colored 1929 deck, celebrating the discovery and colonization of the Americas, uses the Spanish suits of Cups, Coins, Clubs, and Swords. The 10 and 11 of Swords show the famous navigators Ferdinand Magellan and Miguel López de Legazpi, respectively. And the 12 of Swords depicts King Philip II of Spain—popularly referred to as Philip the Prudent.

5

VIUDA E HIJOS
DE HERACLIO FOURNIER
VITORIA

TIMBRE DEL ESTADO
1,20 PESETAS

5

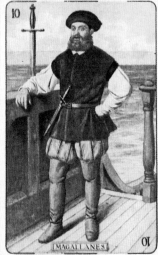

10

MAGALLANES

10

2

1

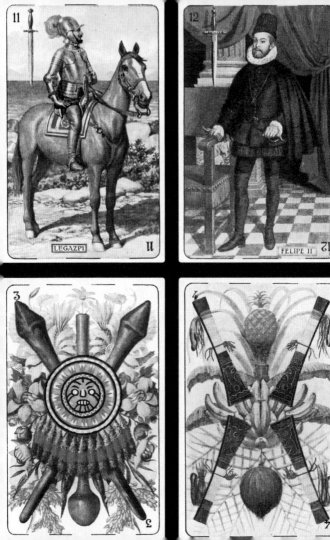

After everyone's had an opportunity to exchange, the play follows this pattern: third betting round, second exchange phase, fourth betting round, third exchange phase, fifth betting round, fourth exchange phase, sixth betting round.

If two or more players remain at the sixth round of betting, the game is decided by a showdown, the players show their hands, and the best hand wins the game, and all of the money bet in the game.

If two or more players have the same highest hand type, the *pip* or *stud* values of the cards are calculated as follows: Ace = one, 2–10 = face value, Jack = eleven, Queen = twelve, King = thirteen. For a draw, both players pick a card at random and the highest card wins.

- Quad: The highest ranking wins
- Prial & rider: The highest ranking wins
- Bouncer: The highest ranking wins
- Run: The highest ranking wins
- Flush: The values are all totaled up and the higher number wins
- Pairso: The values are all totaled up and the higher number wins
- Pair & kickers: The values are totaled up and the higher number wins
- High card & tags: The values are totaled up and the higher number wins

NAGS

Nags is a unique game with a simple but absorbing method of play based on horse racing. To play you will need two to five players and a standard 52-card deck.

INVENTED BY
Andrew Brewood
and Francis Irving
at New Card Games

No. of players: 2–5 Difficulty: medium

AIM

Score the most points by playing out all the cards you have in your hand.

DEALING

Deal four cards face up—these cards are the *horses*. If any of the cards are the same rank, put the extras back in the pile and put down new cards so that all four horses are represented by cards of different values.

Nine cards are dealt to each player, representing the *riders*. The remaining cards form the draw pile. The Ace is played as higher than the King and lower than the 2.

PLAY

The first player puts down the lowest 2 they have, of the lowest suit they have. The suits go, from low to high: Clubs, Diamonds, Hearts, and Spades. So if a player had a 2♣ they would play that as their lowest 2 and could also play as many 2s as they had onto the discard pile. If the first player had no 2s, they would start with 3s, and if no 3s they would start with 4s, and so on.

To take their turn, players put down a card or cards onto the discard pile, playing a card (or cards) of the same number as, or one higher than, the one on the top of the discard pile. Numbers can't be mixed—a player could put down three 2s but not a 2 and a 3. If a player can't put down a card, they should turn over the top card of the draw pile to form the discard pile and miss the rest of their turn.

Winning Horses: If a player puts down a card of equal value and color to one of the horses, that horse *comes in*. The player picks up the horse card from the runner's enclosure, and remembers what position the horse came—i.e., whether it came first (was it the first horse won in the game) or second, and so on.

Falling Horses: If a player puts down a card of equal value and opposite color to one of the horses, that horse *falls*. Once a horse has fallen, it can't then come in. If a person plays more than one card of the same value as one of the horses, as long as one is of the same color, the horse comes in.

GAME OVER
The game finishes when a player puts down the last cards in their hand, and scores are totaled up to determine the winner. If no one has won but the draw pile has run out, the discard pile should be turned over and used to replace the draw pile, with the top card flipped to start off the new discard pile.

SCORING
The player who got rid of all of their cards scores five points, plus an extra one point for each card that the other players have left in their hands. Horses that have come in score points as below:

- 1st: a number card scores its face value, and after that, J = eleven points, Q = twelve points, K = thirteen points, and Ace = fourteen points
- 2nd: half its face value
- 3rd: one third of its face value, rounded off
- 4th: one quarter of its face value, rounded off

CUCKOO

To play you'll need a standard 52-card deck and two or more players. In Cuckoo, players have a certain number of *units* or *lives* that are lost to the player and go into the communal pool to be taken by the winner. You can play for money, or just pick some objects to represent your player's units—you can play with coins, cornflakes, or whatever you've got handy. Aces are high.

ALSO KNOWN AS
Ranter Go Round,
Chase the Ace, Spit
on Your Neighbor,
Beggar Your Neighbor,
Moogle, or Marinara

No. of players: 2+ Difficulty: easy

AIM

Avoid having the lowest card in your hand when all the cards are revealed at the end of the game.

DEALING

The dealer deals out one card face down to each player.

PLAY

The player to the left of the dealer starts by deciding to keep their card, or saying to the person on their left, "change"—the other player must then exchange cards with them, unless they have a King, in which case they can say "King," and refuse. When a player says "King," the game skips the rest of their turn. Whenever a player has to give an Ace, 2, or 3 in response to a change command, they must say out loud what the card is.

The last turn of a hand is the dealer's, and if they want to exchange their card, they should cut the rest of the pack and

take the top card. If they pick up a King, they lose the hand and one of their lives goes into the pot. If they don't draw a King, everyone shows their hand and the player with the lowest card loses and must put a unit into the pot. If there is a draw of one or more players, everyone puts in a unit. The game goes on until everyone has lost their units and is out of the game—the last player still with a unit is the winner.

This 1929 deck celebrates the discovery and colonization of the Americas, and a distinctly military motif runs throughout. These Sword cards represent five famous Spanish conquistadors. Going clockwise from top left, they are: Vicente Yáñez Pinzón, Vasco Núñez de Balboa, Hernando de Soto, Juan Ponce de León, and Juan de Grijalva.

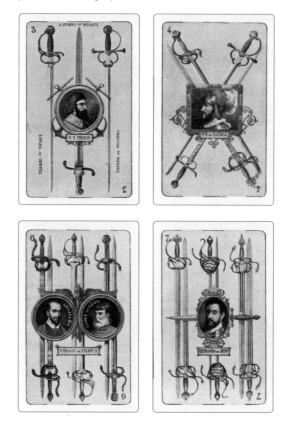

99

There are a few games called 99, but this one is a creative yet simple version great for groups of two or more players where at the end of each round more rules are made up. Fun times! You'll need a standard 52-card deck to play.

ALSO KNOWN AS
98

No. of players: 2+ **Difficulty:** medium

AIM

Be the last person in the game by trying not to go over 99 and thus hang on to your tokens.

GAME TIP
Try to get a hand that can survive 99 being reached to avoid being kicked out of the game, so save 10s, 4s, 9s, and Kings and play cards of high value to bump the total up and make it harder for everyone else.

DEALING

Three cards are dealt to each player; the rest form the draw pile. Each player also gets three tokens (e.g., game chips).

PLAY

The player to the left of the dealer goes first, picking one of their cards, placing it in the discard pile and saying its value, (e.g., if they have a 3, they would say "three"), and then taking a new card. The next player does the same, adding the value of their card to the previous card and calling out the new total. If anyone forgets to pick up a card before the next player goes, they don't get to take a card after they've realized. The game goes on until a player can't put down a card without taking the total number over 99, and then they lose one of their tokens and the round ends. When a player loses all their tokens they are out, and as play goes on, the last player with any tokens left wins the game.

SCORING

The cards have point values and special properties:

- 4: zero points, and reverses the order of play (but once the game is down to two players, the order cannot be reversed)
- 3: three points, and the next player misses a turn
- 10: minus ten or plus ten points, as the player decides
- 9: 99 points
- King: zero points (or is *see through*)
- Queens: ten points
- Jacks: ten points
- Aces: one or eleven points, as the player decides
- All other cards: worth their face value

NOTE
The back of this deck shows some truly beautiful detailing, with intricate knotwork set off by vibrant, lush orange and red.

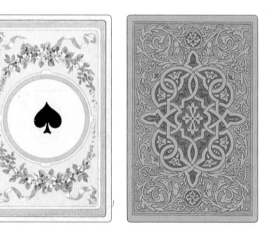

DUCK SOUP

Duck Soup, a game for two players, is played in two *courses*. During *Duck*, the first course, after putting down a card both players take the top card of the stockpile, bringing their hands back up to thirteen cards. In the second course (*Soup*), which begins when the stockpile runs out, hands are played out to the end. You'll need a standard 52-card deck, and note that Ace is low in the first course and high in the second.

INVENTED BY
David Parlett

No. of players: 2 Difficulty: challenging

AIM

Win *tricks* (rounds of the game) especially tricks containing cards of different suits. Play up to 250 points.

GAME TIP
It maximizes your profits to win a medium number of tricks in both Duck and Soup rather than winning many in one course and few in the other.

DEALING

The dealer deals thirteen cards one by one to each player and places the rest face down to form a stockpile.

PLAY

The nondealer plays the first card, and the winner of a trick may start the next. The following player may then play any card, with no need to *follow suit* (play a card of the same suit). There are no *trumps* (cards which outrank all other cards).

During Duck (first course of the game), the trick is won by the lowest card of the suit led (played first), and the Ace is played low. During Soup (second course of the game), the trick is won by the highest card of the suit led, and the Ace is played high.

If a player wins a trick that contains two of the same suit, e.g., two Spades, it is stored face down next to them. A trick that contains different suits scores double points, and to indicate this, is stored face up. Whoever wins a trick draws first from the stockpile (if there are still cards), waits for the other player to draw, then leads to the next.

If the opposition leads a trick and the other player plays a card of the same rank as the one led (e.g., a 3 on a 3), you must say "quack!" If you fail to say "quack," your opposition wins the trick, which scores double. If you remember to quack, then the leader of the card must do one of the following:

• say "duck," and you as the quacker win the trick and store it face up, or
• play another card of the same number and say "quack-quack." This forces you into playing another card. If it is the fourth card of the same number, you can say "Duck Soup," win both tricks and store them face up, but if it isn't, the leader wins both tricks, storing the first trick face up and the other trick face up or down depending on whether or not your last card followed suit to the third card played.

If your opposition quacks, and you have the third card of the same number you don't have to play it—you can also duck. After a quack-quack, both players draw two replacement cards from stockpile rather than one. If not enough are left, only twelve tricks will be played in the Duck course.

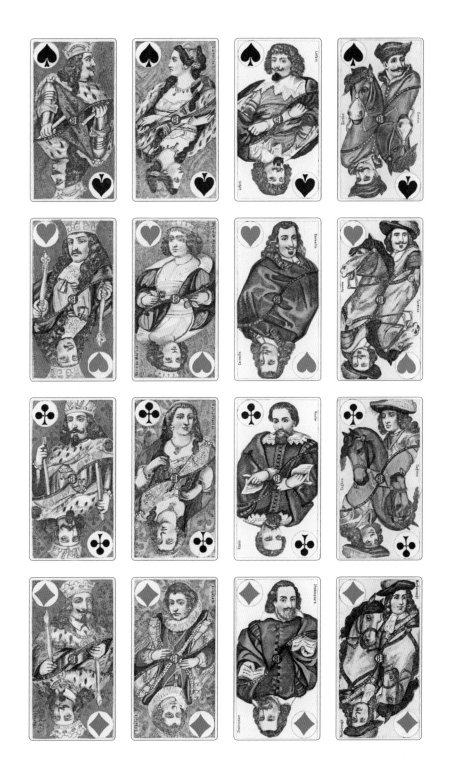

SCORING

Once the last card has been drawn from the stockpile in the Duck round and before the next trick is played, the points scored so far are totaled up, counting one point for each face-down and two for each face-up trick. The tricks from this first course are put separately to one side.

Score the Soup course in the same way. To calculate the final score, multiply both scores for the individual courses.

The Queen of Clubs depicts Marie Thérèse Charlotte of France, the eldest child of Louis XVI and Marie Antoinette, and one of the few survivors of the family after the Reign of Terror.

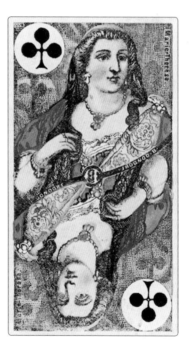

SLAPJACK

This is a simple game for two to eight people, and especially good for younger members of the family. Play with a standard 52-card deck with Jokers removed.

No. of players: 2–8 Difficulty: easy

AIM
Win all the cards by being first to slap each Jack.

DEALING
Deal the cards one at a time face down to each player until the whole pack has been dealt out—the hands don't need to be exactly even. Players make their cards into a pile face down and don't look at them.

PLAY
To take their turn, each player takes their top card and places it face up in the center. If the card played is a Jack, the first player to slap his hand down on the Jack wins it, as well as any of the cards underneath it. The winner turns them over and shuffles them into the rest of their pile. When several players slap at a Jack at the same time, the one who got there first wins the cards. If anyone panic-slaps at a card that isn't a Jack, they must pass a card face down to the player of that card. The game continues until one player has won all the cards.

GET AN EXTRA LIFE
If a player runs out of cards, they stay in the game until the next Jack turns up, when they can slap at the Jack in an effort to get a new pile. If they fail, they are out of the game.

DRACULA

INVENTED BY
David Parlett

Dracula is a nice math-based game for two or four players—we'll explain the two-person version first and then the four-person. It can be played as a betting game, so grab yourself some chips, coins, or other units of currency to play with. You'll need a 54-card deck, including two Jokers—these are your *vampires*.

No. of players: 2–4 Difficulty: medium

AIM

Make a line of three cards with the highest score.

DEALING

Each player picks a card, and the one who draws a red suit (or if both cards drawn are red, whoever draws the highest red card) is the first dealer. There are two ways to score— horizontally (the Queen's way) or vertically (the King's way), and before they deal the first dealer decides which way they will take, leaving the other player the other option. The player taking the Queen's way can only score points with horizontal rows and the player taking the King's way can only score points with vertical columns.

There are six deals to a game, and players take turns dealing. Four cards each are dealt face down, and the next card face up to become the eventual center of a grid of nine cards. The rest are placed face down to form the stockpile.

PLAY

You will gradually build up a layout of three columns and three rows (called the *coffin*) with the card that was turned face up in the center. The nondealer plays first, and puts a card down in any of the open positions around the first card. Note that you can only put a card down if it has another on top of or beside it—you can't just go corner to corner. Play goes on in this way until all positions have been filled, and then the points are totaled up.

SCORING

Each player scores the total of the highest-value line of cards in the direction you're playing. If the values are equal, score your second-highest lines.

- Number cards: face value
- Jack: zero in all directions
- Queen: ten horizontally, but zero vertically
- King: zero horizontally, but ten vertically
- Ace: one

The value of a line can be affected by the following. If it . . .

- contains two cards of the same suit, it doubles its value
- contains three cards of the same color, it triples its value
- contains three of the same suit, it quintuples its value

A vampire (Joker) drains the points from the row and column, meaning the line counts zero both horizontally and vertically. The coffin is then gathered and placed to the side, and the game starts again, using cards from the stockpile. Once six rounds have been played you each take note of your final total score.

FOR FOUR
Each player is dealt thirteen cards, with a vampire included in the dealer's partner's hand, and in the hand of the left opposition player, who also puts the first nail in the coffin. Play and turn to deal rotates left.

GAME NOTE
If you have a King, Queen, or Jack with zero points, you can still count the suit/color for doubling, tripling, or quintupling the score of the line.

NERTS

ALSO KNOWN AS
Pounce, Racing Demon,
Peanuts, Squeal,
or Scrooge

Nerts can be thought of as a kind of competitive Patience or Solitaire game, but for two or more players played with one 52-card deck per person. Note that each deck must have a different back design or scoring will be impossible. With more than five individual players it gets a bit hectic, so if you have an even number of six or more, team up in twos and use one deck each playing as partners. Aces are low.

No. of players: 2+ Difficulty: easy

AIM

Be the first to lose all of the cards from your Nerts pile.

DEALING

Each player deals themselves out a Nerts pile of thirteen cards, twelve face down with the last card right side up on top. Everyone then deals themselves four cards face up, side by side, as their four work piles. The rest of the cards make up the player's stockpile, which will be turned over three at a time, and will form the player's waste pile.

The card layout in Nerts should end up looking something like the image on the opposite page.

PLAY

If in their work pile a player has an Ace, it's placed in the *foundation* area, where during the game you can place the next higher card of the same suit on it if it is the top card of the Nerts pile, a work pile, or the waste pile, until you reach

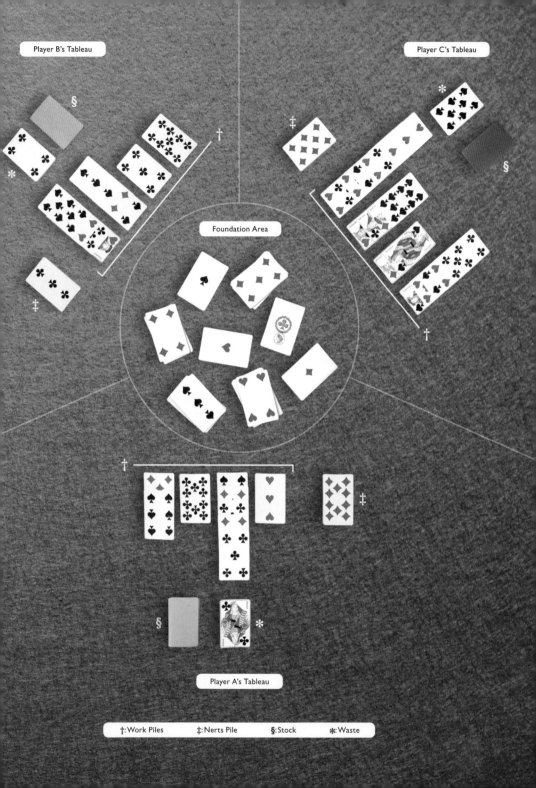

Player B's Tableau

Player C's Tableau

§

†

‡

§

‡

Foundation Area

†

†

†

‡

§

✳

Player A's Tableau

†:Work Piles ‡:Nerts Pile §:Stock ✳:Waste

the King. The cards left—the stockpile—are placed face down in front of the player.

Players all start at once and play as quickly as possible—the faster the better. To start, each player turns over their stockpile in threes.

The work piles begin with one card each, and are built up throughout the game from high to low and in alternating color, the cards overlapping, e.g., a black 7 is placed on a red 8. Any card in a work pile can be moved onto any of the other work piles, and any cards on top of the card to be moved go with it. The resulting space can be filled with a nerts-pile card, a waste-pile card, or a card from another work pile. The top card on any work pile can be played onto the foundations.

If you empty a work pile, replace it with a face-up stock-pile card or the top of the Nerts pile. If you remove the top of the Nerts pile, turn the next card face up.

The first player to empty their Nerts pile ends the game, calling out loud "Nerts!" and then scoring takes place. The player who got rid of their cards first gets a ten-point bonus, and any player who placed a King on a foundation gets a five-point bonus.

All players then score points equal to the number of cards they placed in the foundation with the number of cards left in their Nerts piles deducted.

GET STUCK

This is an ingenious meld of card game and board game for two or four players. We'll go through the two-player version first and then the four-player version. You'll need a 52-card deck. Before beginning each player chooses whether they will play red or black.

INVENTED BY
David Parlett

No. of players: 2–4 **Difficulty:** medium

AIM

Players are aiming to be the last player able to turn a card down, and also to turn down lower-scoring rather than higher-scoring cards.

Card values are:

- Ace: one
- Number cards from 2–9 (there are no 10s): face value
- Face cards: ten to the winner but minus ten to the loser

DEALING

Remove all four 10s from the pack to make a 48-card deck. Shuffle the cards and arrange face up in seven rows of seven, leaving a gap in the very center of the grid. (See the illustration on the next page, which is after eight turns have been played.)

PLAY

To start, the nondealer takes a card of their own color that is horizontally or vertically in line with the gap, moves it into the space, and turns it over, leaving another space where

this card came from. The play continues in this way, following the rules that run as follows:

• When moving to the gap, a number card (including an Ace) may not jump a face-down card. Only face cards (Jack, Queen, and King) may jump cards lying face down. (For example, in the illustration here, you can move the J♥ to the right but not the 4♥.)
• If you can make a horizontal or vertical move, you must do so. If you cannot, you should instead move a card of your color that lies in a diagonal line with the gap. As before, only face cards can jump over face-down cards.
• If you can't make a vertical, horizontal, or diagonal move, you're stuck, and have lost the game.

SCORING

The last player to move scores the total face value of all number cards of your color still face up, with a ten-point bonus for each of your face-up face cards. The loser scores the total value of all number cards of their color still face up, with a ten-point minus for each of the face-up face cards.

FOR FOUR

North and South are partners and play respectively Spades and Clubs. East and West are partners and play respectively Hearts and Diamonds. Each player takes the undealt 10 of their suit and places it face up on the table before them as an indicator card. The other 48 are dealt out as in the game for two. The game lasts for four deals, and the partnership with the highest score wins.

The turn to make the first move and the turn to play rotates to the left. At each turn players move a card of their own suit to the gap and turn it face down. You can move

your card up and down, left and right, and diagonally, though only a face card can jump over a card face down.

When a player gets stuck, they turn their 10 face down. This does not prevent moving on a later turn if the opportunity arises, and if you can move again, you should do so, turning your 10 face up.

Once both members of a partnership get stuck, with both their 10s face down, the game ends. Score as per the two-player version, except that the winning side gets a bonus of 50 if both its members have their indicators face up when the game ends.

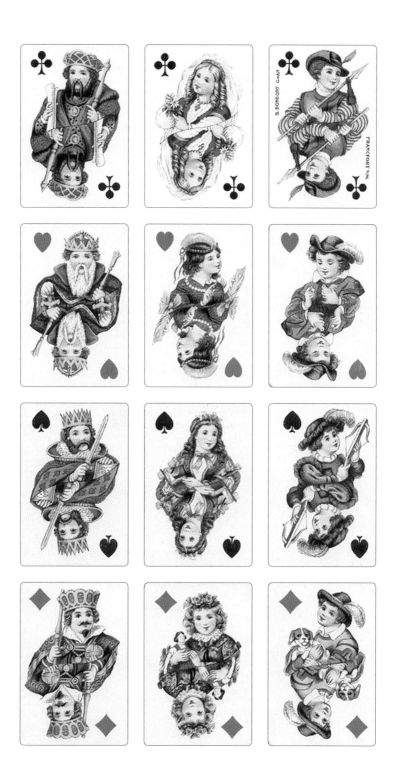

SNEAK

INVENTED BY
David Parlett

Sneak is a not-too-serious game for a group wherein you either collect cards to make a winning combination or bluff your friends into thinking you have one. For up to four players you can use a 52-card deck, though for five or more use two packs shuffled together to be sure everyone has enough cards. Aces rank both high and low, as the player decides.

No. of players: 2+ **Difficulty:** challenging

AIM

Win more cards than any other player by *sneaking* (bluffing) and *challenging* when you think other players are sneaking.

DEALING

The dealer simply shuffles the cards and places them face down in the center to become the stockpile.

PLAY

The player to the left of the dealer plays first, and takes the card on the top of the stockpile and adds it to their hand. Regardless of game events, the turn to play always passes to the left in rotation.

After the first turn where everyone does this, on their turn players can:

Draw: Take a card from the stockpile.

Sneak: Place a card or cards face down in the center to try to win cards by bluffing. If none of the other players challenges (calls their bluff), you win these cards without having to turn them over, and put them aside into your winnings pile.

Flaunt: Place a card or combination face up in the center to try to win cards by force. If none of the other players challenges or beats the cards placed, you can add them to your winnings pile.

Combo: A combo is a combination of two or more cards of the same number, suit, or sequence. Only combos containing the same number of cards can be played against one another. Combos beat each other from high to low as follows:

- Watch: two or more cards of the same rank (e.g., 2-2, Q-Q-Q)
- Straight flush: two or more cards in suit and sequence (Aces can be played high or low, so both A♦-K♦-Q♦ and A♦-2♦-3♦ are legal.)
- Straight: two or more cards in sequence but not flush (Ace counts high or low, so A-K-Q and A-2-3 are legal.)
- Flush: two or more cards of the same suit but not in sequence. This is the lowest combo.

Whether you sneak or flaunt, you can't put down a three-card combination if no other players have more than two cards.

If you sneak (put cards down face down), any other player when it's their turn can challenge you by putting down the same number of cards. If no other players challenge, you win the cards, but otherwise, when everyone has taken their turn the sneaker's and each challenger's cards are flipped in turn of play.

If you lead one card, the highest card wins regardless of suit. If you lead two or more cards, the highest combo wins. If you have two combos of the same type, the one with the highest top card wins, or second highest if they are equal. If the highest card or combo is a tie, then the winner is the tied card or combo played last.

If you flaunt (put down cards face up), any other player can challenge by putting down the same number of cards face up. If more than one player announces a challenge, they must put down their challenging combos at the same time. If you put down one card, it can only be beaten by a higher card of the same suit. If you first played a combo, it can only be beaten by a higher combo of the same type—i.e., the one with the highest top card/cards.

If you lead the play with a straight flush, it can only be beaten by another, higher, straight flush. However, if it is played to someone else's lead combo of a straight or a flush, it counts only as a straight or a flush—it doesn't beat their combo just because it's a straight flush. Ties are always broken in favor of the card or combo played last.

When the stockpile has been used up, no more sneaking is possible, and flaunting is the only possible play from here on in. The last player left with any cards in their hand places them in their winning pile, and each player scores one point for every card won. The winner is the player who reaches 100 points first (if playing with one deck) or 200 points (if playing with two decks).

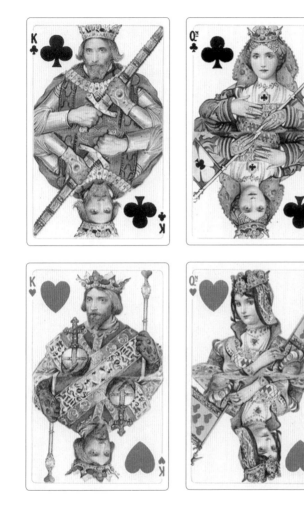

SCOPA

Scopa is a popular Italian card game, taking its name from the Italian for broom. Taking a *scopa* sees a player sweep all of the cards from the table, which is one of the best ways of scoring points in the game.

The game is usually played by two players or two teams; however, it's possible to play the game with up to six players.

Scopa uses a traditional Italian deck of cards. Each suit contains number cards from Ace (one) to 7, then three picture cards: a Knave (eight), a Knight or Queen (nine), and a King (ten). The suits are most commonly Cups, Coins, Swords, and Clubs, however some regions take the French suits of Hearts, Diamonds, Flowers, and Spades.

No. of players: 2–6 **Difficulty:** challenging

AIM

Capture the most cards and have the highest number of points.

DEALING

One player is nominated to be the dealer. He begins with the player to his right and continues counterclockwise around the playing area. The dealer deals three cards to each player (one card at a time) and also places four cards face up on the table. If the table cards contain three or four Kings, the cards must be reshuffled and dealt again!

PLAY

The player to the dealer's right begins. The player can either place a card on the table or play a *trick*.

Playing a trick: This means capturing cards. A capture is made by matching the value of a player's card to one or more table cards. The player's card and captured cards are then placed face down until scoring at the end of the round.

If all table cards are captured by a player, this is called a scopa and the player receives an extra point during scoring. For example:

- Player's hand: 3 of Clubs, 7 of Swords, and 6 of Cups
- Table cards: Ace of Coins, 7 of Cups, and 5 of Swords

1. The player would place the 3 of Clubs on the table, as he cannot capture anything with that card.
2. The player would use the 7 of Swords to capture the 7 of Cups, as they are the same value.
3. The player would use the 6 of Cups to capture both the Ace of Coins and 5 of Swords, as their combined values equal six.

Additional rules of play: Cards with matching values must be played. For example, if a player and the table both have a 7, the player must capture the table 7 with his, even if there is also a 4 and 3 on the table. All cards with the ability to capture must be played. For example, if a player holds a 5 and the table has an Ace and a 4, the player must capture these.

Once all players have played their cards, the dealer deals three more cards to each player. However, he doesn't deal any more table cards. This continues until all cards have been dealt. At the end of the game, the player who most recently captured is awarded the remaining table cards.

SCORING

Scoring takes place after every deal. Players receive one point for each scopa. Players receive an additional point if they:

* Captured the greatest number of cards
* Captured the greatest number of cards from the Coins suit
* Captured the 7 of Coins
* Obtained the highest Prime

In tie situations, no player receives a point.

Calculating the Prime: The Prime is calculated by players selecting their best card from each suit and totaling the points of the cards. A separate scoring system is used for the Prime:

Card	Score	Card	Score
7	twenty-one pts	4	fourteen points
6	eighteen points	3	thirteen points
Ace	sixteen points	2	twelve points
5	fifteen points	King	ten points

Example: A player has the 7 of Cups, 6 of Coins, 6 of Swords, and Ace of Clubs (21 + 18 + 18 + 16 = 73 points). Their Prime is 73. If they have the highest Prime, they receive one point.

Scoring never takes place mid-round and must be at the end of every deal, when all players have played their cards. The game is played until one player has at least eleven points and has more points than any other player.

3+ PLAYERS

CREIGHTS

ALSO KNOWN AS
Craits or Crates

This is a simple, fun game for three or more players. Creights is a modern game, invented in the 1970s in Cambridge, Massachusetts. It is a kind of meld of another game, *Crazy Eights*, from which it gets its name, and Uno, a card game that has its own specialized deck. Luckily, you just need a standard deck of 52 playing cards to play Creights, though if you have more than five players it's better to use two decks.

Note the Spanish suits of this deck, coins and swords. The inscription of the top card, Espada de Isabel I, refers to the "sword of Catholic kings," which was used by the Catholic King Ferdinand and Queen Isabella to knight Christopher Columbus on his return from his first voyage to America.

No. of players: 3+ Difficulty: medium

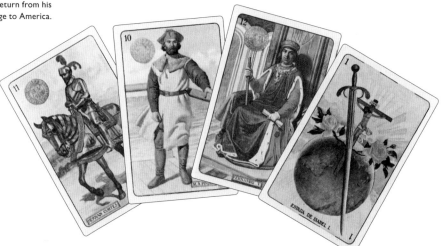

AIM

Get rid of all of your cards.

DEALING

In Creights you play fifteen hands. The dealer starts in the first hand by dealing eight cards to each player, then seven in the second hand, then six cards, and so on until the eighth hand, when each player only gets one card. In the following hands the amount of cards goes back up until you're back to eight cards each in the fifteenth hand. After the cards are dealt out, place the remaining cards in the center of the table, and turn the top card over.

GAME TIP
Try removing the Kings and Queens in a three-player game to result in a greater risk of shuffle pressure.

PLAY

When you turn a card over in Creights, you need to abide by what the card says—most of the cards in Creights have special functions, which go like this:

- Ace: nothing (except if played during a *count*)
- 2: starts a count
- 3: nothing (until you total up the round's scores)
- 4: skips the next player
- 5: a card must be dealt to every other player
- 6: player must play again
- 7: gives a card to the player across the table
- 8: wild (can be substituted for any other card); player calls a new suit
- 9: wild (can be substituted for any other card); player calls a new suit of the same color as the current suit
- 10: reverses the direction of play
- Jack, Queen, or King: nothing

To take your turn, you need to play a card of either the same suit or the same number/rank as the card on top of the discard pile, or an 8 or a 9, which are considered wild cards and can be substituted for any other card—you choose which. If you can't play any cards, then you need to draw a card from the stockpile and miss a turn.

Whenever a player gets down to one card, they need to say "one card." If they forget to do this, they miss a turn and need to draw two cards from the stockpile—these are called "idiot cards."

A hand ends when a player plays their final card, except if it happens during the count, in which case the game continues as normal.

The count: **When you turn over a 2, the count or *crank* begins,** starting at the number two. During a count, the normal rules of the game are suspended, and every player then needs to play either a 2 or an Ace, increasing the value of the count by either one or two, depending on the card played. When one of the players can't play an Ace or a 2 because they don't have one in their hand, they must pick up from the stockpile as many cards as are in the count, and miss the rest of their turn.

SCORING

At the end of the game, the player with the lowest score will be declared the winner, so it's a good thing to get very few points in a hand. The person who gets rid of their last card gets 0 points, and the remaining players then total up their score based on the cards they have left.

Card	Score		Card	Score
Ace	one		8	fifty
2	twenty		9	thirty
3	three (see below)		10	twenty-five
4	fifteen		Jack	ten
5	thirty		Queen	ten
6	thirty		King	ten
7	twenty			

When you're totaling up, a 3 can be used to replace another higher value card; that is, you could use your three to replace a King in your hand so you're only scored three rather than ten. This works for every card but an 8 or an Ace, which can't be replaced. Any 3s left which cannot cover a card earn you 100 points, but in the lucky event that you only have 3s left, each 3 you have gives you -50 points.

Shuffle penalty: If the stockpile runs out when a player needs to draw a card, they must shuffle the discard pile (except for the top card which is kept separate as the start of the new discard pile), and add a *shuffle pressure penalty* to their point score. The first shuffle pressure penalty a player gets adds five points to their score, with each subsequent shuffle pressure doubling its value. For example, a second shuffle pressure will be ten points. Note that shuffle pressure penalties are individual to players and continue throughout all fifteen hands. The penalties for the shuffle pressures are independent for each player, and double throughout the game.

If you need to draw a card and there are no cards in the stockpile and no cards in the discard pile but for the top card, then you get a shuffle pressure penalty, and the round ends.

SPOONS

Spoons is a great game for a big group, especially in a party setting. Prepare for spilled drinks and an atmosphere so tense you could cut it with, well, a spoon.

No. of players: 3+ Difficulty: easy

AIM

Get four of a kind—for example, four 5s, four 2s, and so on. The other, more vital, aim of Spoons is to avoid being the last person without a spoon.

DEALING

Each player will be dealt four cards to make up their hand. The dealer should place the rest of the cards in the reserve pile. A number of spoons should be placed in the middle—one less than the number of people playing.

PLAY

To begin, each player should simultaneously take one card and pass it face down to their left, and pick up the card passed to them by their neighbor. The exception to this is the player on the right of the dealer, who should put one of their cards down on the table to start the discard pile, while the dealer picks up a new card. Repeat this motion for each play. The first person to get four of a kind should pick up a spoon—either by subtlety and stealth, or in a completely unsubtle and slightly deranged lunge. The last person without a spoon is the loser.

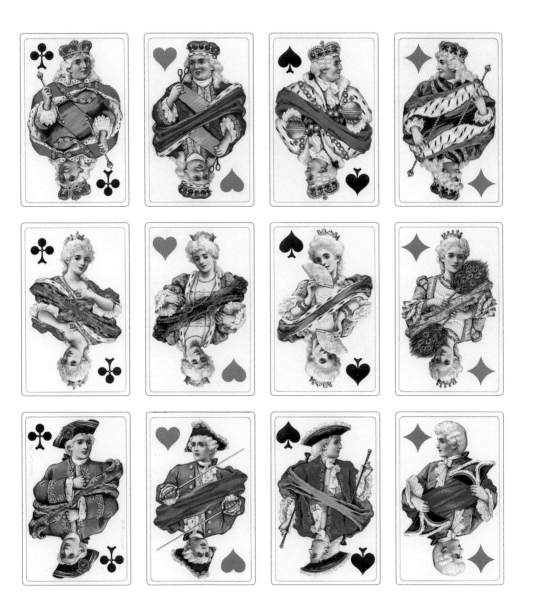

CHEAT

ALSO KNOWN AS
Bullshit, Bluff, Chaarso
Bis, 420, or I Doubt It

This is a very fun and social game, great for groups. You'll need three to eight players and a standard 52-card deck with Jokers removed—if you're playing with more than six use two decks so everyone has enough cards. Aces are low.

No. of players: 3–8 Difficulty: easy

GAME TIP
Think twice about ordering your hand so that all of the cards of the same rank are put together—it's useful for you, but it can also tip off the other players as to what kind of cards you have.

AIM

Get rid of all your cards. Players try to sneak cards into hands and claim they are something other than what they are, thus *cheating* the other players.

DEALING

Distribute all of the cards among however many players there are. It doesn't matter if the hands aren't all even.

PLAY

The idea is that you put down one or more of the same ranked cards down—as you're trying to get rid of your cards, putting down multiples of the same card in one go is a good idea.

The first player takes their turn by discarding one or more cards face down on the pile, and saying what they are—it's good practice to start off by putting down—or saying you're putting down—an Ace or two.

As the play goes round the table, the cards being called out go up—so the next player after one who put down an Ace would put down some 2s and say "two 2s," the next

player, "one 3," and so on. If you get all the way up to Kings it then starts again at Aces.

You don't actually have to have the cards that you're saying you put down, the idea is to fake it to get rid of more cards, but you have to try not to get caught.

If a player doesn't have any of the next card, don't put down three or four as it's likely that someone else will have at least two of these cards, will call "cheat" and you'll have to turn over your cards to prove you were telling the truth.

Any player who suspects another player of cheating can call "cheat" or "I doubt it," the cards are exposed, and one of two things happens:

1. If the cards are correct: The challenger was wrong, and has to take the whole discard pile.
2. If the cards are a cheat: The challenger was right, and the player who put down the cards has to take the whole discard pile.

After a challenge has been made, another round is started by the last person to play.

Whoever gets rid of all their cards first wins the game. If you play your last card, but someone challenges you and your cards are cheats, you pick up the pile.

NEWMARKET

Newmarket is a great game for three to eight players.

No. of players: 3–8 Difficulty: easy

AIM

Be the first to get rid of your cards and win bets by playing
certain cards. You'll need a standard 52-card deck and another
deck to pick cards from (or some pens and paper to make
stand-in cards). Aces are high.

DEALING

Take a Jack, Queen, King, and Ace, all from different suits,
out of one deck, and put them side by side in the middle—
these are the *boodle* cards.

The whole second pack is then dealt out between the play-
ers, including one more hand than there are players (e.g.,
with three players four hands are dealt)—this is the *dummy*
hand and is just placed face down on the table.

PLAY

Each player places a pre-agreed stake into the pot to be
won, as well as putting an additional stake down on each
boodle card.

The first player puts down in front of them a card of any
suit they wish, but it must be the lowest card they hold in
that suit. Whichever player has the next highest card of that
suit has to now play it, putting it down in front of them-
selves, as does the next player until either the Ace is reached

or no one has the next higher card of the suit. A *stop* card is a card that players cannot follow, because no one has the next card in the suit. There is no central card pile; when a player plays a card it goes down in front of them on their pile, such that the card below (if there is one) peeps out from under.

If a player puts down what is the last card in a sequence (either an Ace or a stop card), they should begin a new run. They do this by putting their lowest card of a different suit down on their pile in front of them, and play continues as before.

The first player to get rid of their hand wins the pot, and when a player plays the same card as any of the boodle cards, they win the stake that's been put down on that card. If any boodle cards still have a stake on them at the end of a game, they carry over to the next game.

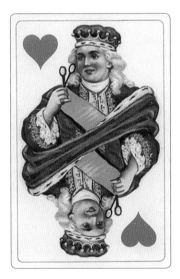

When compared with the other Kings in this deck, who are all carrying more regal items such as scepters or a sovereign's orb, the King of Hearts seems a little out of place with just his scissors.

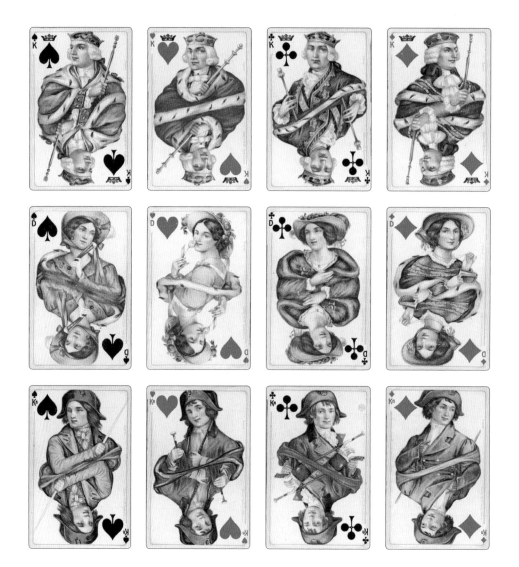

CUTTHROAT

Karma is a game that nearly everyone has played, so we've decided to introduce you to Cutthroat—Karma's bigger, tougher cousin. Like Karma, it's based on a mixture of strategy and luck, but it's harder, faster, and even more evil than the original, so strap yourselves in for a great ride.

No. of players: 3+ Difficulty: challenging

OPPOSITE
This very romantic deck was produced by Dondorf for the Danish firm Adolph Wulff (1879–1948) of Copenhagen. The expressions on the faces of the characters are wonderfully detailed.

AIM

Like Karma, the aim of Cutthroat is to avoid being the last to get rid of all of your cards. To do this, you need to play cards in your hand that are equal to or better than those played by the previous player. Ordinary cards go from lowest to highest in this order: 3, 4, 5, 7, 9, Q, K, A. In Cutthroat, there are also two kinds of special card, *power cards* and *rule cards*. We'll come back to these after introducing you to the basic flow of play.

DEALING

Each player will be dealt four cards that are kept face down, and on top of these, three more that are dealt facing up. Players are then also dealt four face-down cards to be kept separately. This is your hand, the four cards you will play to try to equal or better the previous player.

PLAY

When a player plays a card or cards from their hand, they should replace it with some from the reserve pile—you should

GAME TIP #1
To make things interesting, why not come up with a forfeit for the loser?

always have at least four cards in your hand until the reserve runs out. Once the reserve is gone, players should pick a card from their face-up four. Once these are gone, players need to pick from their face-down four. Note: the first pick-up from your face-down four is a freebie—this means you can turn over a card, and if you don't like it, you leave it face up and pick another.

The first player selects and plays any card from their hand. As an example, let's say a 5. The second player needs to play a card of equal or higher value—for example, a 9. (If you have more than one card of the same number you can place them all down in one turn.) If the player hasn't got anything of higher or equal value, they have to pick up the pile of cards and incorporate them into their hand. The player that has just lost that *trick* goes next, laying the next card. Got all that? Now on to the special cards . . .

SPECIAL CARDS

Power cards: **2, 3, and 8.** These can be played on almost any other card, regardless of how high they are. Power cards can't be played on a 6 (see 6 rule).

When a 2 is played, it means that the next player can play any card at all. This means you need to be careful when placing a 2, as it gives the next player a lot of power.

3 is the *match* card. If you play a 3 on a 7, it is a 7. 3s can't be used on 10s or Jacks (see 10 rule, Jack rule). If a 3 is the first card played in a new game, it has nothing to match, so it is a zero.

8s reverse the order of play. When you play an 8, the next player has to play a lower card for that turn. You only play less for that turn.

Rule cards: **6, 10, and Jack.** These can only be played in numerical order, so for example, you can't play a 6 on a 7 or better.

Laying a 6 means that the next player must play one of the face cards, so a Jack, Queen, King, or Ace. A 6 can be played on a 6, of course—a card always matches its own.

10s clear the deck. All cards in the deck get discarded for the rest of the game, the 10 included. A 10 is not a power card or a face card.

Laying a Jack means that the next player must play one of the power cards, so a 2, 3, or 8. Remember that although the Jack's special ability is to force the next player to play a power card, it isn't a power card itself, and needs to be played in order—i.e., it can't be played on a higher card.

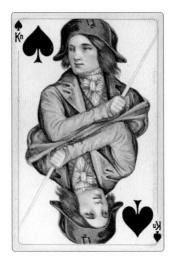

In the seventeenth century, "Jack" started being used for the proper term "Knave." "Jack" became even more popular after 1864, when cardmaker Samuel Hart published a deck marking them as "J" instead of "Kn." This Jack uses the old Kn for "Knave."

UP & DOWN THE RIVER

ALSO KNOWN AS
Oh Hell!, Oh Well!,
Blob, or Blackout

This is a nicely strategic 1930s game which first appeared in London and New York. Its original name Oh Hell! has been changed to many more polite alternatives including Up and Down the River, Oh Well!, Blob, Blackout, and Nomination Whist. The French name Elevator or *l'Ascenseur* gives a nod to the way the hands are played *up and down*.

Three to seven people can play, though the game is the most fun with four or more. You will need a standard 52-card deck, and Aces are high. A full game takes about 40 minutes to play.

No. of players: 3–7 **Difficulty:** medium

AIM

The aim of the game is for each player to bid the exact number of *tricks*, or rounds of the game, they think they can win, and then try to win exactly that many—no more and no less. At least one person won't make their bid on each hand, because the total number of tricks that could conceivably be won in the hand might well be less than the total number of the players' bids.

UP & DOWN

Each successive hand is played with one fewer card, going all the way down to a hand of just one card each, then back up one card at a time, to the starting number of cards. For example, if you had seven players, the hands would be played with seven cards, then six, then right the way down to

one, and then would turn around and start going up again, from two, to three, all the way up to seven.

DEALING

Cards are dealt out according to how many people are playing. With three to five players, ten cards are dealt each; with six players, eight cards are dealt each; with seven players seven cards are dealt each.

After the cards have been dealt, the dealer turns a card over from the pile of unused cards—the suit of this card determines the trump suit for that round, the suit that outranks each of the other three suits. The rest of the cards should then be placed in a face-down stack with the trump card on top.

PLAY

The player to the left of the dealer starts by saying how many tricks they can take, one by one everyone does the same, ending with the dealer, and then the bids are recorded on a score sheet. You can't skip bidding, but you can bid zero, in which case you try to win no tricks. The dealer cannot bid a number that would mean the total number of tricks bid would equal the number of tricks available.

The first card played (by the player to the left of the dealer) can be a card of any suit, including the trump. All players following on after the first player must play cards of the same suit first played, if they can. If they can't, they can play any other card in their hand, including any cards of the trump suit. Whoever put down the highest trump card at the end of a hand—or if a card of the trump suit wasn't played, the highest card of the suit first played—wins the round, or the trick. The winning player then takes the first play, putting down a card of the suit of their choice, for the next round.

OPPOSITE
These replica cards were handmade by Simon Wintle, using a process working with woodblocks and stencils to create a set as close as possible to the antique pre-industrial card-production methods.

After each hand the cards are swept back into the deck and the dealer deals out cards individually until everyone has the right number of cards for the hand being played.

Once all the tricks have been played (from, e.g., seven cards in a hand and down to one, and then back up to seven) the score is totaled up to determine the winner.

SCORING

Each trick won gets a player one point, and any players who won exactly the number of tricks they bid get ten points. For example, if someone bid three and won three, they would score ten for bidding the exact number of tricks, plus three for the three tricks actually won.

As time went on, the Kings, Queens, and Jacks in vintage decks became closer and closer in appearance to what modern card players may be familiar with from playing with a standard deck. Note however the delicate lines of the faces, still imperfect due to being drawn by hand.

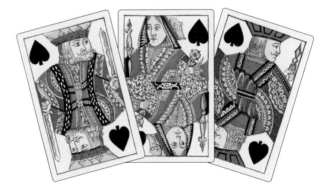

FAN TAN

ALSO KNOWN AS
Sevens, Domino,
or Parliament
Fan Tan is a simple game for from three to eight people. You'll need a standard 52-card deck. Aces are high.

No. of players: 3–8 **Difficulty:** easy

AIM
Get rid of all your cards.

DEALING
The dealer deals all of the cards in the deck out to the players one at a time. The turn to deal rotates clockwise as the game proceeds.

PLAY
Cards are put down and added to a layout that consists of one row of each suit, building up toward the Ace on the left and down toward the 2 on the right, around the 7, that is the card that is always in the middle.

The first player takes their turn as follows. If they can, the player should either play a 7 of any suit, which will start off a new row for that suit, or play any card that is one higher or lower to a card of the same suit already on a row. If you're playing in a small space, piling the high cards on top of the 8s and the low cards on the 6s reduces the space needed. If they are unable to play a card, they miss a turn and knock on the table, but you may not pass if holding a card that can be played. The player to get rid of all their cards first is the winner.

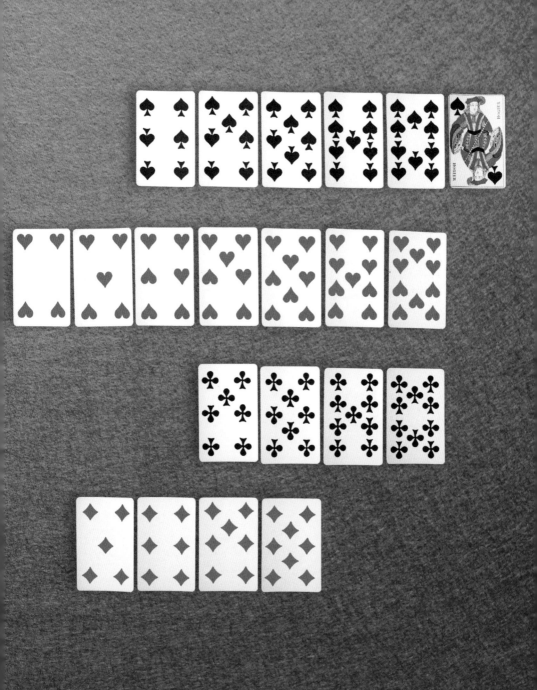

PIP-PIP!

Pip-Pip! can get quite noisy, but it's great fun for a party. You'll need three to twelve players and two 52-card decks shuffled together. The card rankings are unusual—2 is the highest card, followed by the Ace, then the King, Queen, and Jack in descending order and so on down to 3.

No. of players: 3–12 **Difficulty:** medium

AIM

Win the most points possible by winning *tricks* (rounds of the game) containing high-scoring cards.

DEALING

Players each draw a card and the holder of the highest card wins the honor of being dealer—the suit of their card also sets the first *trump* suit. The dealer deals seven cards to each player and the rest become the stockpile.

PLAY

The cards captured will give you points as follows:

- 2: eleven points
- A: ten points
- K: five points
- Q: four points
- J: three points
- All other cards: zero points
- A *Pip-Pip!*: fifty points

The player to the left of the dealer leads the first trick and the rest of the players must *follow suit* (play a card of the same suit, ideally higher) if they can. If following suit is impossible, players should put down a card of the trump suit, or any card they want to get rid of.

The trick is won by the player who put down the highest card of the trump suit, or if no trump cards were played, who played the highest card of the suit led. When two identical cards are played, the second one wins. The winning player puts the trick down in front of them and takes a replacement card from the stockpile, as do the other players. The winner then leads the opening suit for the next trick, but before they can, there is an opportunity for scoring points with pip-pips.

Pip-pip: Any player after drawing a card who now has a King and Queen of the same suit (but not the trump suit) may call "pip-pip!" and put the cards down face up in front of them, scoring 50 points and changing the lead suit for the next trump to that of the King and Queen. If two players call a pip-pip at the same time, each gets 50 points, though the suit is changed to the one laid down by whoever was first to call pip-pip. You can hold on to your pip-pips to play them at the best time. Cards that have been played in a pip-pip can still be played in tricks as normal, but cannot be reused for another pip-pip. A player may call "pip-pip!" twice in the same suit if they have both Kings and Queens of that suit. A player may also call "pip-pip!" before the first trick in the hand should they be dealt appropriate cards. In this case the trump suit changes prior to playing the first trick of the hand.

If they have been dealt the cards in their first hand, a player can call a "pip-pip!" before the first trick, in which case the trump suit decided upon is superseded by whatever the pip-pip suit is.

GAME OVER
Once the stockpile no longer has enough cards for all of the players to take one, the last cards are turned over, all play their final cards in the final round, and scores are marked.

CARD EXPLOSION

INVENTED BY
Nic Giacchino
bouncy_weasel@
yahoo.com

Card explosion is a Cheat-style game most fun to play with three or more friends. You'll need a 52-card deck which is tweaked to become a 45-card pack consisting of all number cards (2–10) of each suit, all four Jacks, one King, two Aces, and two Jokers.

No. of players: 3+ **Difficulty:** medium

AIM
Be the first to get rid of all of your cards.

DEALING
Deal the deck out until there is no longer enough to equally give everyone the same amount of cards. The surplus cards are placed face up in the center to start the play pile.

PLAY
Play starts clockwise (though the direction of play can be changed by playing a Jack—more on this later), each player taking it in turn to put down a card.

The fundamental idea is that you must play a card one lower than, equal to, or one higher than the top card of the play pile, which will have on top the card played by the last player. There are also special cards or *bomb* cards that can be played—we'll come to these later. If a player can't put down a card or wants to pass, they may do so. If any player plays an *illegal* card or puts down a card when it is not their turn, they must pick up the play pile and skip a turn.

Bomb cards: Bomb cards can be played on top of any other card and have special properties. When playing a bomb card you must count down (e.g., "three, two, one") speaking as fast or as slowly as you like, but absolutely clearly. One transgression gives you a warning and a failure to *detonate* your bomb card; a second misdemeanor kicks you out of the game. The reason a clear countdown is important is that as you do so, the next player must put down a card that follows the usual rules—equal to, or one greater or lesser than the bomb card—or another bomb. If the player being bombed fails to put down a card before the bomber gets to "one" in their countdown, the cards *explode* on them, and they pick up the play deck and skip a turn. When being bombed, passing is not possible.

There are four types of bomb cards, each with the following special characteristics:

• Jokers, or *nukes*: cause instant explosions and do not require countdowns. When a Joker is played on the center deck, the next player must pick up the deck.
• Jacks, or *tricksters*: reverse the direction of play and may be played on any card but a bomb.
• Kings, or *shields*: these are defensive cards which block any bomb, including nukes, when placed on top of them during your turn. You may wish to save your King for use at the best strategic time.
• Aces: these are an add-on for bomb cards which turn them into *missiles*. When playing an Ace, you must put a bomb card on top of it, and then choose a *target*, counting down if it is a true bomb card, or not if it was a nuke. If the missile is defused, the target plays next, though if it explodes, the target's next turn is skipped. Shields can still block missiles.

GAME NOTE
Kings can only be used defensively when being bombed, Aces can only be played on a bomb card, and Jacks may not be used to deflect a bomb card.

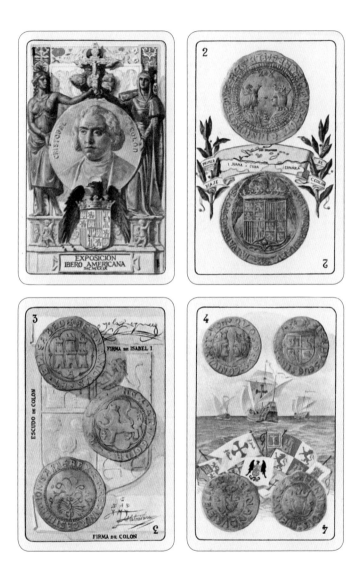

KINGS

Many people will have played Kings a time or two before with disastrous consequences—this is a softer version, with the alcoholic forfeits replaced with good clean silly fun. The brave (or foolhardy) could add a few back in as part of their own house rules, but don't say we didn't warn you! You'll need a 52-card deck and three or more people to play.

ALSO KNOWN AS
Circle of Death, King's Cup, or Ring of Fire

♠ ♥ ♣ ♦

No. of players: 3+ Difficulty: easy

AIM

Make it to the end of the game with your dignity intact.

DEALING

Cards are shuffled and dealt in a ring, face down on the table.

PLAY

The dealer goes first, drawing a card at random from any in the ring and turning it over. The player or players must then act out whatever the corresponding card command requires.

Suggested commands are as follows, but feel free to tweak it to make it your own:

OPPOSITE
The Ace of Coins (top left) in this Spanish deck refers to the inspiration for deck itself—the Ibero-American Exposition of 1929. This world's fair was held in Seville, Spain, and was meant to boost Spain's foreign relations, particularly with its former colonies.

• Ace: the drawer of the Ace must lick the card, stick it to their forehead, and dance to a song of the group's choosing until the card falls off.
• 2: the player must speak with a strong accent until another player turns over a 2.
• 3: the direction of play switches.

- 4: the player may use a permanent marker to draw on a fellow player of their choosing.
- 5: the player gives an amusing nickname to a fellow player. From now on everyone must refer to the player by their new nickname—failure to do so results in shaming by the group (e.g., booing, throwing bits of paper, noogies, etc).
- 6: put your thumb on the table without anyone noticing. The last person to put their thumb on the table loses, and must tell the group an embarrassing story.
- 7: everyone must raise their hands in the air—the last person to do so loses, and must do an animal impression.
- 8: choose another player to be your friend or "mate"; whatever you have to do, they must do the same as well.
- 9: the player says a word, and the next players must say words that rhyme with it. The loser must make an unflattering face and pose for a picture.
- 10: the player makes a statement starting with "never have I ever"; all players who have done the thing mentioned must raise their hand.
- Jack: the player must whine about something, anything—preferably something ridiculously trivial—and the whining goes around the group until a majority of players deem a whine not whiny enough or a player can't think of anything to say. The least whiny player must attempt to cry on demand.
- Queen: the player who draws this card initiates a staring contest between two other players. The player to lose the staring contest must keep one eye closed until it is their turn again.
- King: the player who turns over a King may make up a new rule.

The game ends when the last card of the ring has been turned over.

CALABRESELLA

Calabresella means *the little Calabrian game* and refers to the region of Calabria, the *toe* of the boot shape that makes up the Italian Peninsula. Calabresella is known for being highly skilled and is most commonly played with three players and a special Italian card deck which has 40 cards. The classic suits are Cups, Coins, Swords, and Clubs, and the ranking is as follows, from high to low: 3, 2, Ace, King, Knight (or Queen), Jack, 7, 6, 5, 4.

No. of players: 3 Difficulty: challenging

ALSO KNOWN AS
Terziglio

IMPROVISE AN ITALIAN DECK
If you don't have an Italian deck on hand, adapt a standard deck by removing the additional number cards, playing the Queen as a Knight, and using the usual suits as stand-ins for the Cups, Coins, and Swords.

AIM

To take *tricks* containing valuable cards and to be the first to score 21 points. The cards have point values and players must try to take tricks containing these cards:

• Ace: one point
• 3, 2, King, Knight, and Jack: one-third of a point

Winning the last trick also means a player receives one point.

DEALING

The dealer deals each player four cards at a time. They each have twelve cards, and four cards are placed face down in the center of the table. Those cards are known as the *monte*.

BIDDING

Each player has one chance to bid, starting with the player to the dealer's right and continuing counterclockwise around the table. The highest bidder plays alone against the other two players. There are three bids, from lowest to highest:

1. Chiamo: where the bidder can call a card from his opponents and exchange cards with the monte.
2. Solo: the bidder cannot call a card but can exchange cards with the monte.
3. Solissimo: the bidder does not call a card or exchange any cards.

Each player can pass or bid, but each bid must be higher than the one before it. For example, if a player bids Solo, the next player must pass or bid Solissimo. If all three players pass, the cards are shuffled and re-dealt.

Calling a card: If a player bids Chiamo, they must state which card they want, which is usually a high card. He may take the card from his opponent or the Monte, depending where it is in the game.

Taking the monte: If the bid was Chiamo or Solo, the bidder turns the monte cards face up. They are then added to the bidder's hand. If the bid was Chiamo and the bidder obtained his called card, he can choose one unwanted card and give it to the player who held the called card.

The bidder then forms a new monte from four of their cards. The value of these cards will count for the winner of the last trick, so all three players should then have twelve cards.

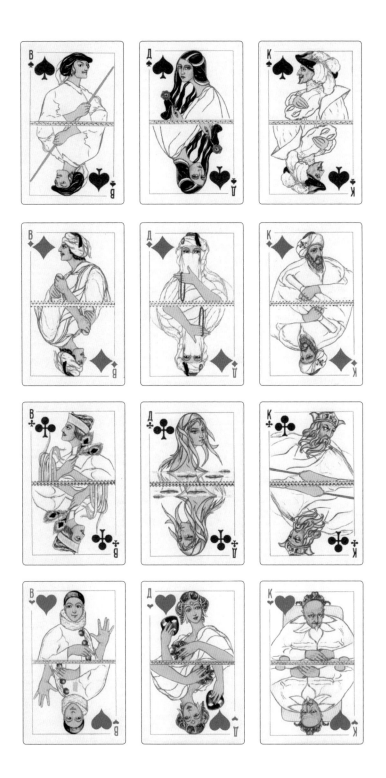

Solissimo: if the bid is Solissimo, the monte remains on the table. No one sees these cards until the winner of the last trick takes them at the end of play.

However, the bidder can choose to increase the stake, changing the game to a Solissimo aggravato. This can take place in two ways:

• Dividete: the opponents draw two cards each from the monte, without showing the other players, and discard any two of their cards face down on the table.
• Scegliete: the monte is turned face up and the opponents can choose which cards they take, discarding the same number of cards face down on the table.

With Scegliete, the opponents do not have to take two cards each. One player can take one card and the other can take three, for example.

PLAY

The player to the right of the dealer leads the first trick unless the bid was Solissimo. In this case, the bidder leads. The player with the highest-ranking card in the leading suit wins the trick and leads the next one.

SCORING

After all tricks have been played, the winner of the last trick takes the monte and all players total their points. The bidder must have six or more to win, and he will then receive an amount from each opponent. If the bidder doesn't have six or more points, he must give the same amount to each opponent.

The amount is dependent on the bid, as follows:

- Chiamo: one
- Solo: two
- Solissimo: four
- Solissimo—dividete: eight
- Solissimo—sceliete: sixteen

The scoring can be affected in two ways:

1. Cappotto: if the bidder wins or loses all tricks, the amount won or lost is doubled.
2. Stramazzo: if the bidder wins or loses all the points without winning or losing all the tricks—i.e., if the tricks won by the losing side equal less than one point (not including the point for the last trick)—the amount won or lost is tripled.

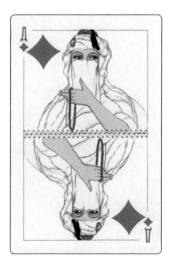

Keeping up the literary theme, the Queen of Diamonds is Scheherazade, Persian queen and the storyteller of *One Thousand and One Nights*.

DOU DIZHU

Dou Dizhu originated in the Anhui province of East China, but has since spread in popularity across the whole country, and is now played extensively online. The game is commonly played with three players and a deck of 54 cards, made up of a standard deck and its two Jokers.

No. of players: 3 Difficulty: challenging

RANKING
Suits are irrelevant in the game, but the cards rank from high to low as follows:

red Joker
black Joker
2
Ace
King
Queen
Jack
10
9
8
7
6
5
4
3

AIM

Be the first player with no cards left.

DEALING

One of the players shuffles the cards and the player to his left cuts the pack, placing them face down in the center of the table. One card is placed face up in the middle of the deck.

Starting with the dealer, the players take turns to pick a card from the top of the pack, which they can look at. This continues counterclockwise until all players have seventeen cards. The last three cards are left face down on the table.

THE AUCTION

This determines who will be the *landlord*. The player who drew the face-up card during dealing starts. He may bid one, two, or three. Players can either pass or bid higher than the number before them. The auction ends when there are two consecutive passes or someone bids three. The highest bidder

is now the landlord and must pick up the three cards from the table, so he has a total of twenty cards. He must now play against the other two players.

PLAY

The landlord starts by putting down a single card or a combination. Play continues counterclockwise around the table, with players either passing or beating the previous player with a higher combination of the same number of cards and same type. There are two exceptions to this rule:

1. A *rocket* can beat any combination.
2. A *bomb* can beat any combination except a higher bomb or rocket.

After a pass, the next player can start again with any card or combination. There are thirteen combinations:

1. Single card: ranking from 3 to red Joker
2. Pair: two cards of the same rank, from 3 (low) to 2 (high)
3. Triplet: three cards of the same rank
4. Triplet with an attached card: a triplet with any single card added—e.g., 6-6-6-8 (these rank according to the rank of the triplet, so 9-9-9-3 beats 7-7-7-A)
5. Triplet with an attached pair: a triplet with a pair added, with the ranking as above—e.g., Q-Q-Q-6-6 beats 10-10-10-K-K
6. Sequence: at least five cards of consecutive rank, from 3 up to Ace—e.g., 5-6-7-8-9
7. Sequence of pairs: at least three pairs of consecutive ranks, from 3 up to Ace—e.g., 10-10-J-J-Q-Q

OVERLEAF
The painter Friedrich Karl Hausmann (1825–1886) was a friend of Bernhard Dondorf and designed a considerable number of items for him. The court cards are dressed in the traditional clothing. The suit of Spades show a sultan, his wife, and a janissary (a sultan's bodyguard); the suit of Hearts portrays a Great Mogul, an Indian princess, and an Indian warrior; the suit of Clubs depicts the Spanish King Ferdinand, Queen Isabella, and a Spanish ambassador; Diamonds illustrate the emperor, the empress, and a mercenary soldier.

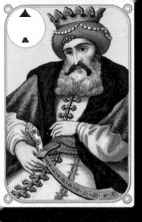
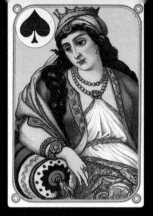
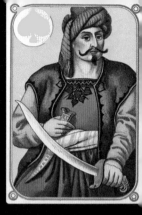
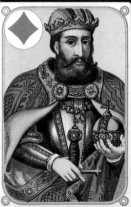
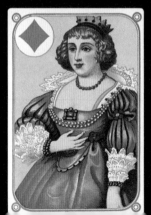
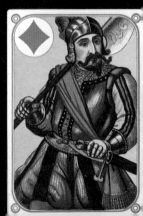

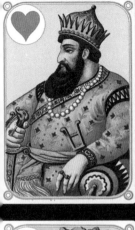
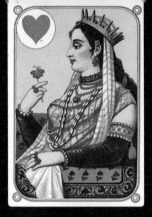
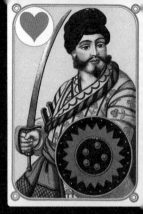
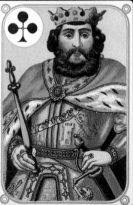
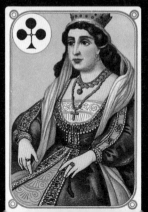
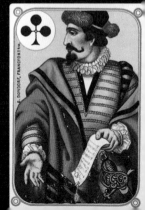

8. Sequence of triplets: at least two triplets of consecutive ranks from 3 up to Ace—e.g., 4-4-4-5-5-5 (Jokers and 2s cannot be used)

9. Sequence of triplets with attached cards: an extra card is added to each triplet—e.g., 7-7-7-8-8-8-3-6. The attached cards must be different from all the triplets and from each other. A two or a Joker can be attached, but not two Jokers.

10. Sequence of triplets with attached pairs: an extra pair is attached to each triplet. Only the triplets have to be in sequence—e.g., 8-8-8-9-9-9-4-4-J-J. The pairs must be different in rank from each other and as well as from all the triplets. Although triplets of 2s cannot be included, 2s can be attached. Attached single cards and attached pairs cannot be mixed—e.g. 4-4-4-5-5-5-6-7-7 is not valid.

11. Bomb: four cards of the same rank. A bomb can beat everything except a rocket, and a higher-ranked bomb can beat a lower one—e.g., 4-4-4-4 will beat 3-3-3-3.

12. Rocket: a pair of Jokers. It is the highest combination and beats all other combinations.

13. Quadplex sets: there are two types—

• A quad with two single cards of different ranks attached, e.g., 4-4-4-4-8-9.
• A quad with two pairs of different ranks attached, e.g., J-J-J-J-10-10-Q-Q.

2s and Jokers can be attached, but players cannot use both Jokers in one quadplex set. These quadplex sets are ranked according to the rank of the quad. A quadplex set can only beat a lower quadplex set.

SCORING

The first to run out of cards is the winner of the game.

• If this is the landlord, each of the other players must pay him the bid amount (one to three units), as long as there were no bombs or rockets played.
• If this is one of the other players, the landlord must pay both opponents the bid amount.

If a player played a bomb or rocket, the payment is doubled each time. For example: if a hand contained two bombs, one rocket, and the bid amount was three, 3 x 2 x 2 x 2 = 24. So, 24 would be the amount to pay.

The four Aces here illustrate the corresponding parts of the world that the court cards on the previous pages call home.

 The two players playing against the landlord equally benefit from the game. Therefore, they can help each other to run out of cards during gameplay.

BUGAMI

ALSO KNOWN AS
Bleeding Hearts

INVENTED BY
David Parlett

Bugami is a variant of the trick-taking card game Hearts (see page 149) and uses lots of its themes and vocabulary. The game uses a standard 52-card deck, which ranks from high to low (Ace to 2) and can be played by three to seven players. Another pack of cards is needed for *bid* cards.

No. of players: 3–7 Difficulty: medium

AIM
Reach the agreed target of points.

DEALING
A player acts as dealer and deals out all of the cards one at a time until everyone has the same number. If any remain, the dealer puts them face down to the side. From the second deck of cards, each player must take their bid cards (one card of each suit).

PLAY
Players look at their cards and decide on their *bug* suit. This is the suit that they will try to avoid having in their hand i.e., a penalty suit. Players must then choose the bid card that corresponds to their bug suit and place it face up. All players can then see each other's bug suits.

You can bid *Misère*, which means all of your bid cards are played face down and you can take no tricks.

Playing tricks: The player to the left of the dealer plays a card which leads to the first trick. Players must *follow suit* if they can, or play any card if not. The winner of the trick is the player with the highest card of the leading suit. The winner leads the next trick. If any cards were left undealt, they are added to the trick and go to the player who won it.

SCORING

A player receives ten points for each trick won. The total is divided by the number of bug suit cards in the trick.

• A player wins four tricks and has one bug suit card = $40/1 = 40$ points
• A player wins four tricks and has three bug suit cards = $40/3 = 13$ points (approximately)

Fractions are not counted so an approximate score is used. Tricks with no bug cards are worth twenty points, so if you have three clean tricks, you receive 60 points.

There are also special scores within the game:

1. A player receives 100 points if they win every trick, irrespective of bugs, and everyone else scores zero, unless they bid Misère.
2. A player receives 30 points if they didn't take any tricks at all, unless they bid Misère.
3. Players who bid Misère receive 100 points if they are successful and zero points if not.

The game ends when a player reaches an agreed target, e.g., 250 points.

OVERLEAF
This nineteenth-century deck is what is known as a "transformation deck," where the suits of the cards are combined in the bodies or faces of the characters on the cards. There is a wonderful creativity and sense of humor to the incorporations, especially in the 6 of Spades. Off with his head!

SPOIL FIVE

ALSO KNOWN AS
Twenty-five
or Five & Ten

Spoil Five is a very old game, dating from at least 1674 when English writer Charles Cotton described it as "Five Fingers." It's considered the national game of Ireland, and in Irish the word for five, which is *cuig* (pronounced coo-ig), also means *trick* (a round of play). To play, you'll need three to eight players and a 52-card deck.

No. of players: 3–8 **Difficulty:** medium

AIM

Be the first to score 25 points.

DEALING

The dealer deals five cards out to each player, places the rest of the cards face down to become the stockpile, and turns over the top card to determine the *trump* suit (the suit which outranks all other suits in the game).

PLAY

If playing for money, each player starts with a pre-agreed amount, and puts one unit per game in to form the pool for the game. The pool is limited to a certain pre-agreed amount, usually a small amount, but you can play with counters or tokens if you prefer or dispense with this element altogether.

Whether a card is high or low depends on the color of the suit and whether it is the trump suit. The highest card of the trump suit is the 5, then in descending order, the Jack, Ace of Hearts, Ace, King, Queen, and then 10 down to 2.

Regardless of the suit that is trump at the time, the Ace of Hearts is always a trump. For all other suits, the King is the highest card followed by the Queen, Jack, Ace, and the numeric cards.

There's also a tricky difference in how the number cards of nontrump suits are played. For nontrump red suits, the number cards rank from 10 to 2, while for black suits, they rank from 2 as high to 10 as low.

The dealer turns over the top card of the stack, which sets the trump suit. At this point, if they have the Ace of the trump suit a player can *rob* this top card—in other words, put face down the worst card in their hand and take the Ace, leaving the trump suit the same.

To start play, the person left of the dealer leads a card and the rest of the players each put down one card, attempting to play the highest card in order to win the trick. Players must *follow suit* (put down any card of the same suit led), or if they wish, put down a card of the trump suit. If the lead card is a trump card, the rest of the players must play trumps if possible, except the top three. If you can't follow suit, you can put down any card you wish. The highest card played of the leading suit wins the trick, unless a trump is played, in which case the highest trump card wins. The last trick's winner starts the next trick.

SCORING

Five points are scored per trick to the team or winner who won it, and to score five points will usually take two or more deals.

Once someone reaches 25 points, winning five tricks, they are the winner and the game is over. If 25 has not been reached by the end of the round, the next person to deal deals a new hand.

GAME TIP
It sounds difficult, but the rankings will come naturally after a game or two—just remember *highest in red, lowest in black.*

GAME TIP
A common rule declares that if one player or team wins a game by winning all five tricks they are entitled to double whatever the stake was—so in this case the losing players will need to pay in another stake to the winner's pool.

501

501 is a Russian card game which is thought to be a hybrid of the Russian game 1000 and German game 66. The game is played with three players; however it can be played with four players if each takes turns to be the dealer and is not active within the game.

501 uses a 24-card pack, with cards ranking from high to low (Ace to 9). Each card has a point value:

- Ace: eleven points
- 10: ten points
- King: four points
- Queen: three points
- Jack: two points
- 9: zero points

No. of players: 3–4 **Difficulty:** challenging

AIM

Be the first to reduce your score of 501 to zero or less.

DEALING

Any player can deal first and the game continues clockwise around the playing area. The dealer shuffles, then the player to the dealer's right cuts the cards. The dealer then deals a card at a time to each player and the table (face down). Each player will have seven cards and the table will have three face-down cards, known as the *talon* or *pickup*.

PLAY

Starting with the player to the dealer's left, the players bid. The lowest bid is 66 and each bid after that has to be higher than the last. Players may choose to pass or bid when it is their turn. The bidding continues until a bid is followed by two passes. The highest bidder then plays against the other two players. If all three players pass, the cards are shuffled and dealt again.

Blind bidding: A player can choose to bid blind, which means his cards stay face down on the table. If he is the highest bidder, his point score is doubled for that hand. A blind bidder can look at his cards at any point; however, his points are no longer doubled if he is the highest bidder.

The talon cards are then turned over and given to the highest bidder. This player chooses the *trump* card, or no trump, and bids the minimum number of points he will attempt to take, know as the *contract*. This must be equal to or higher than his original bid.

The player then passes a card face down to the two other players, so everyone then has eight cards in their hand. If the highest bidder sees the talon and realizes they can't hit their bid in points, they can state this. The bid amount is then added to the player's score and the other players can subtract 25 points each from theirs.

Playing tricks: The player to the left of the dealer leads the trick. Players must follow suit or play a trump of any value if this isn't possible. If a player can't follow suit or play a trump, he may play any card. The winner of the trick is the player with the highest trump or, if there are no trumps, with the highest card of the leading suit.

Declaring a marriage: **If the player leading the trick has a King and Queen of a suit, he may declare a marriage.**

• The player says "forty" if the marriage is of the trumps suit and receives forty points.
• The player says "twenty" if the marriage is of another suit and receives twenty points.

For the player to receive these points, he must win at least one trick in the hand. If the highest bidder chose no trump, marriages are all worth twenty points and tricks are won by the highest card in the leading hand.

SCORING
All players start with 501 points.

After all eight tricks are played, the players count their points, including any marriages. If the highest bidder was successful with their contract, the number of points is subtracted from their score. The other two players subtract their points from their score.

If the player conceded after seeing the talon, their bid or contract is added to their 501 points and the other players can subtract 25 from theirs.

If the last bid was a blind bid, the bid amount is doubled but the other players still only subtract 25.

If a player's score is 100 or fewer, they cannot subtract points if the highest bidder conceded. The player can only win points by having a successful bid or contract.

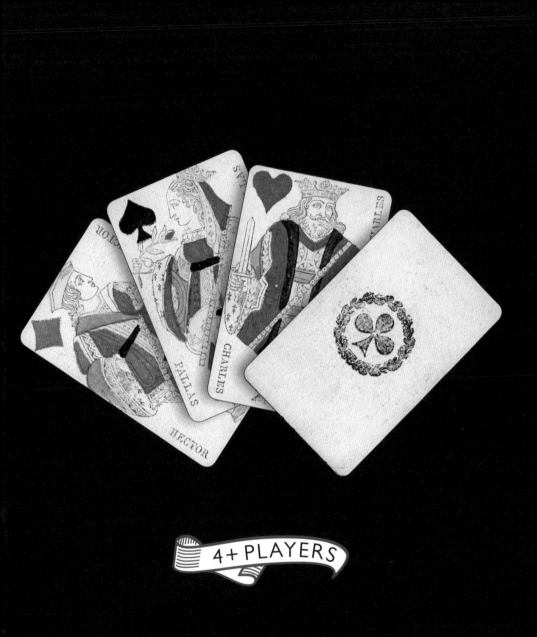

4+ PLAYERS

PRESIDENT

The great thing about this game is that it can be tailored so nicely to wherever the players are from, using local words for bigwig and social outcast as substitute for the US-centric President, Vice President, Citizen, and Scum. Pick your own four terms and come up with your own forfeits for the loser and you'll have a whale of a time. Requires four to seven people and a standard 52-card deck. Card rank is unusual and 2 and Ace rank above the King, with 2 being the highest card in the game. If you have six or more players, use two decks.

No. of players: 4–7 Difficulty: medium

AIM
Get rid of all of your cards as soon as you can. The last player left with any in their hand is called the Scum, or whatever term of derision is locally used.

DEALING
Deal out all of the cards in the deck one at a time to all players.

PLAY
The first player starts by putting down face up any one card or any set of cards of equal rank, e.g., three 7s. The rest of the players then must either pass, skipping putting down any cards, or put down a card or set of cards which betters the previous card. One card can be beaten by any one higher card, or a set of higher cards. A set of cards can only be bettered

by a set containing the same number of cards with higher numbers. You're not required to put down cards just because you can—you may decide to pass at any time, putting down no cards. To make it more fun though, pick a penalty that those who pass must do.

The game goes on in this way until a card or cards are put down that all players pass on. When this happens all the cards played are flipped over and placed to one side, and the player who played last starts the game again.

The first player who runs out of cards wins the highest social rank, e.g., President, the next Vice President, then Citizen. The last player to be left with any cards is known as the Scum. Decide what perks the President and Vice President get throughout the game—the nice chairs? Massages? As in life, mere Citizens get nothing, but the Scum is actively persecuted by penalties of your choice.

For example, at the start of the next round, the Scum should gift their highest card to the President, and the President must give them back any card they don't want.

In the traditional French deck, each of the Jacks represents a specific historical figure: J♣ is Lancelot, J♥ is La Hire (a famous French military commander), J♦ is the Greek hero Hector, and J♥ is Ogier (a legendary Danish knight).

PINOCHLE

ALSO KNOWN AS
Binocle

Pinochle can be thought of as beginner's Bridge, and takes a little while to get the hang of, but once learned it's a fantastic game, especially for couples. You'll need four people in two teams to play and two decks of cards. Take the 9s, 10s, Jacks, Queens, Kings, and Aces of all four suits from both decks, and shuffle together to make a 48-card deck.

Aces are high, but unusually the card order runs from Aces as highest to 10, King, Queen, Jack, down to the lowest card, 9. For example, the Ace beats the ten, which itself beats the King.

No. of players: 4 **Difficulty:** challenging

GAME TIP
When bidding, it's worth remembering that even if you take all of the tricks in a game, you can at maximum win 250 points (with extra awarded for melds)—so don't bid too high.

AIM

Win *tricks* (rounds of play) that include cards that carry a scoring value when won in a trick and create *melds* (certain combinations of cards) that have values in points.

DEALING

The dealer should deal out all the cards three or four at a time so everyone has twelve each. The players then examine their hands and get ready for bidding.

PLAY

After the cards are dealt, the player to the dealer's left makes a bid that estimates how many points they think their team will win. One person will win the bid, and will then be known as the *declarer*, and they will then be able to:

- Name the trump suit
- Receive cards from their partner
- Lead the first trick

The minimum starting bid is 250 points, and bids are made in increments of ten. After the first player bids, the rest of the players can bid higher or pass—after three people have passed, the winning bid stands; the person who won is the declarer, and may name the trump suit.

Next each player looks at their cards and declares any melds they have—the points from melds are written down, though the cards are kept in players' hands and the scores are not totaled up just yet.

The declarer puts down the first card, and the players following must try to put down cards that *follow suit* (put down a card of the same suit but higher than the card led, and if they cannot, put down any card of the suit led), and that also beat the lead card, meaning if they can't follow suit, they must play a *trump* card. A trump card beats a higher card of the led suit, but if a trump card has already been played, it can be beaten by a higher trump card. If it's the case that two identical cards are played, then it's the first one that was played that wins.

The cards from the won trick are placed face down in front of the winning team, and the player who won the last trick then starts off the next round of play. Once all twelve rounds (tricks) have been played, both teams collect their stacks of pulled cards and count the Aces, 10s, and Kings (the *counters*) won, and total up the points as overleaf.

If the declarer achieved their bid score, they get that many points, and their meld total added on; if they didn't make their bid score, the bid is taken away from their score.

The other team then total up their points for the cards won in their tricks plus the melds they made, although if they didn't win any tricks, they can't score for their melds, and their score is zero.

SCORING
When a player takes a trick, each card in the hand scores points as below. The player who wins the last trick of the game gets a bonus of 10 points.

- Ace: eleven points
- 10: ten points
- King: four points
- Queen: three points
- Jack: two points

Then there are three separate classes of meld values:

Class A:
- Ace, 10, King, Queen, Jack of trumps: 150 points
- King, Queen of trumps (*royal marriage*): 40 points
- King, Queen of a plain suit (*common marriage*): 20 points

Class B:
- Pinochle (Q♠ and J♦): 40 points
- Dis (9 of trumps): ten points

Class C:
- one Ace of each suit
- one King of each suit
- one Queen of each suit
- one Jack of each suit

SNIP SNAP SNOREM

Snip Snap Snorem is a fun and simple matching card game dating from the eighteenth century, which is thought to have given rise to the children's game Snap. You'll need a standard 52-card deck, counters or units of currency (coins or dollars) to play for, and four to eight players. Aces are low.

No. of players: 4–8 Difficulty: easy

AIM

Be the first to get rid of all of your cards.

DEALING

The dealer deals all cards in the pack out to the players one at a time. The turn to deal rotates around the group as the game progresses.

PLAY

The first player puts any card face up in the center, saying "snip." Whichever player has the next-highest card of the same suit puts it down, saying "snap." The holder of the third card in sequence plays it saying "snorum," and then the player with the next-highest card plays it, saying "high cockalorum," with the player of the fifth card putting it down and saying "jingo." The fifth card being put down ends the round, and the player who played the last card now begins again by putting down the snip.

Sometimes the round may end with fewer than five cards because the highest card possible (the King) has already been

reached. In this case the player of the last available card says "jingo" and play starts again.

The player who gets rid of all their cards first wins, and each of the other players must give them one counter or unit of currency for each card they still have in their hand.

This "Bergmannskarte" deck, dating from 1816, shows a variety of scenes from traditional German life, including this picturesque view of Freiberg.

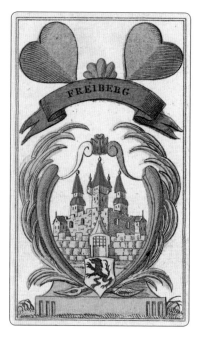

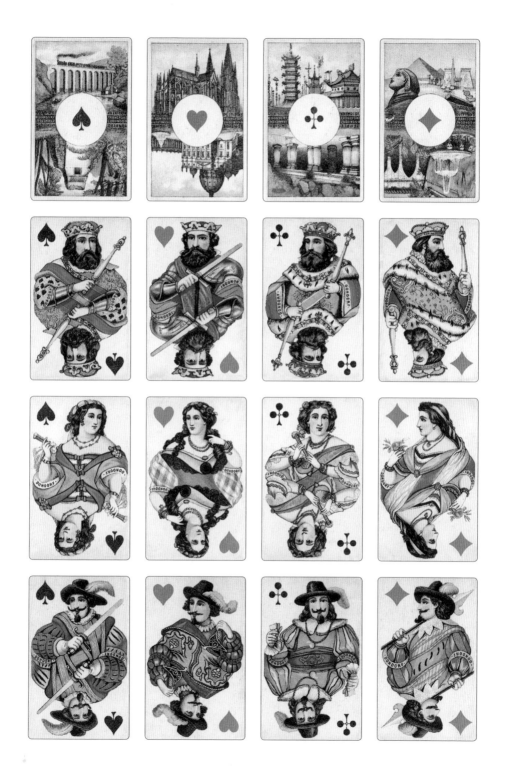

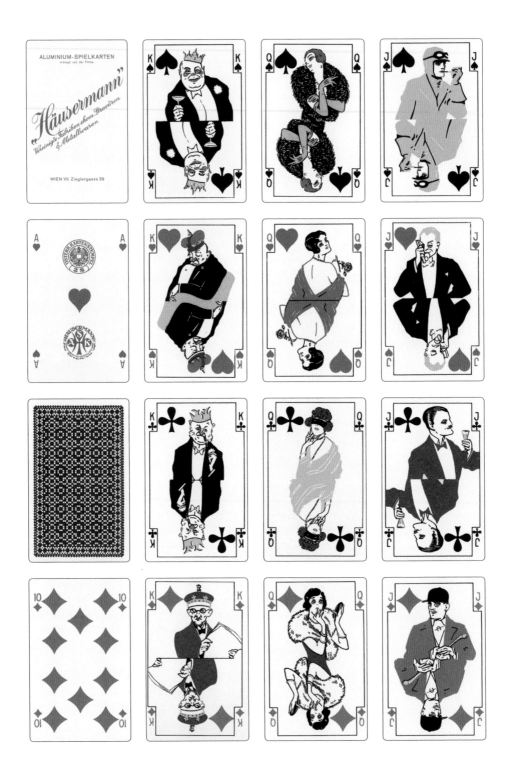

PLONK

Plonk is a trick-taking game where you can play any card rather than having to stick to the usual *follow suit* (play a card of the same suit) rule. There is a catch, however. You'll need four people to play in partnerships and a 52-card pack where Aces rank high.

INVENTED BY
David Parlett

No. of players: 4 Difficulty: medium

AIM

Win *tricks* (rounds of play) that contain cards of suits other than the one first played (the suit *led*).

GAME TIP
Set an agreed target to play up to, at which point the game ends. Try 200 points for a short game.

DEALING

Each player is dealt thirteen cards each, one by one, by the dealer. The turn to deal alternates each hand.

PLAY

In a trick, a card of the same suit of the one led is a *dead* card and reduces your score; all other suits are *live* cards and increase your score.

 The player on the left of the team opposing the dealer puts down the first card, the suit led. When the next player takes their turn, they can put down any card of any suit. The trick is taken by the highest card of the suit led, and at the end of the round the winner of the trick is the one that played the highest card of the suit led.

 The winner separates the dead and the live cards and puts them in the dead or the live card pile, which each team should

OPPOSITE
This is a deck made from aluminum by Häusermann United Chemical and Metal Engraving Co. in Vienna in 1925, with the aim of showing how easy color printing on aluminum was. These cards have fantastic Jazz-age illustrations, with playboys and elegant ladies living it up 1920s-style.

have a pile for in front of them. Whoever wins a trick may lead the first card in the next round, except in the case that nobody follows suit to the card led. In this case the player on the right-hand side of the opposing team leads.

To win you need to play as a team—if your partner is looking likely to win the trick, play a high-ranking live card.

If your competition looks likely to win, play a middle-ranking dead card rather than a high one, as you want to keep your high cards for your partner's tricks, and will want to save low ones to use for your opposition's tricks.

If you can't tell who's likely to win, it's safest to play a low live card. Keep in mind that a trick that contains wholly dead cards gives you minus four points.

SCORING
At the end of the game, each team totals up all the points won by its live cards according to the following values:

- Number cards: face value
- Jack, Queen, and King: ten points each
- Aces: fifteen points
- Dead cards: minus two points each

MEMORANDA

How are your memory skills? Memoranda is a simple yet tricky game to get those synapses firing and is a great game to play with kids. To play you'll need two separate 52-card packs of different reverse-side design or color and four to six players. One of the decks is the dealer's pack, and the other is the player's pack.

INVENTED BY
David Parlett

No. of players: 4–6 **Difficulty:** easy

AIM

Correctly remember which cards you were originally dealt.

DEALING

The dealer doesn't get any cards themselves, but deals the pack out until all players have an equal number of cards. If any are left over, they are placed face down to one side.

Players take 30 seconds to memorize their cards, and when the dealer calls "time!" all players lay their hands face down in front of them.

The dealer then turns the top card of the dealer's pack face up and clearly announces its identity. If a player thinks they recognize the card as one of theirs they call "mine!"

If only one person shouts "mine!" the dealer passes them the card. If no one calls the card, it is put into the *unclaimed* cards stockpile. If two or more players call a card, the dealer puts it into the *disputed* cards pile.

Play continues in this way until all of the cards have been played, with the turn to deal rotating. Scoring takes place

after each round, and the game finishes once all players have been dealer.

SCORING

Once everyone has had a turn dealing, go around and have each player turn over their original hand. Each player will then be awarded one point for every card they claimed to recognize.

For every card remaining in the disputed pile that a player rightfully owned, that player will score the same number of points as there are players in the game (and be sure to include the dealer).

Any card that has been wrongfully received by a player because the true owner did not claim it should then be returned to the unclaimed pile. The dealer scores the same number of points as there are players in the game (again, that includes the dealer) for each card that is left in the unclaimed pile.

This card shows a globe with a cupid surrounded by doves.

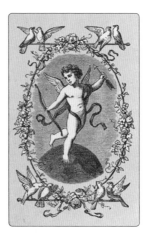

CANDYMAN

Want a game where players play secret roles and sneakiness is rewarded? This is a game perfect for larger groups—you'll need a minimum of four players, with the optimum number being six or more. You'll need a standard 52-card pack.

ALSO KNOWN AS
Drug Dealer

No. of players: 4+ Difficulty: easy

AIM

The cop's aim is to find the candyman as soon as they can, the user's aim is to *buy* drugs successfully and to keep the supply chain open by distracting the cop. The candyman's aim, perhaps unsurprisingly, is not to get caught and to *sell* as much product as possible.

GAME TIP
If winking isn't working for you, you can agree on another physical *tell* to mean a deal has taken place—try touching your face, wiping your lips, or shaking your head.

DEALING

From your deck, the candyman takes one Ace, one King, and enough number cards (of any number) so that there is one card for everyone when they are shuffled together. The rest of the pack is not used in the game. Each player picks up a card and looks at it without showing it to anyone.

The player who has the Ace is the candyman (or drug dealer) and the person with the King is the cop. The rest of the players who have number cards are the users.

PLAY

The candyman tries to sell to other players by winking unobtrusively at them. A user buys by being winked at by the candyman without the cop seeing it, and once this

happens the the user shows their card, says "sold," and is out of the game.

At this point the cop identifies themself, and tries to guess the candyman by pointing at a suspect and saying "busted." The suspect has to turn over their card—if the cop is correct, the round ends; if the cop is wrong, the round continues with the candyman winking again.

At the end of five rounds, the player with the highest score wins.

SCORING

• The candyman gets one point for each successful deal and minus two points if they're caught.
• The users get one point for successfully buying and one point if wrongly busted.
• The cop gets two points for a successful bust and minus one point for each incorrect accusation.

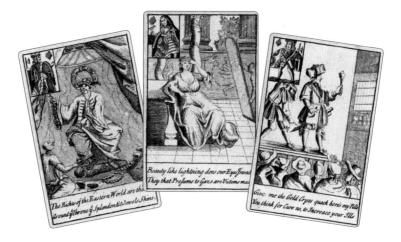

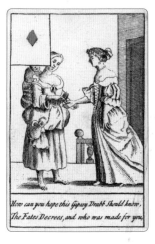

How can you hope this Gipsey Drabb Should know,
The Fates Decrees, and who was made for you.

Phillis I sware, hold, Oaths, can never bind,
A man more fickle than the changing wind,

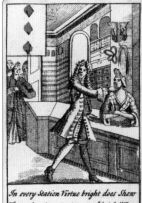

In every Station Virtue bright does Shew
The modest Sempstress scornes ye lustfull Beau.

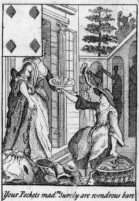

Your Pockets mad!ms Surely are wondrous bare
To Sell your very Cloths for China Ware.

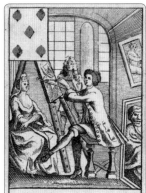

O happy Painter so to Charme the fair,
She cant Conceal one Grace one beauteous air.

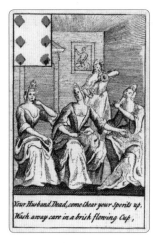

Your Husband Dead, come chear your Sperits up,
Wash away care in a brisk flowing Cup,

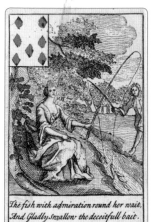

The fish with admiration round her wait,
And Gladly Swallow the deceitfull bait.

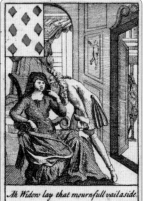

Ah Widow lay that mournfull vail aside,
Altho a Week Scarce past to morrow youl be my bride.

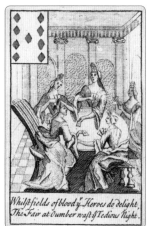

Whilst fields of blood ye Heroes do delight,
The Fair at Oumber wast ye Tedious Night.

SUICIDE

INVENTED BY
Joakim Malmquist
joakim@jade.se

Joakim Malmquist's story of how he came to invent this game of random chance is fascinating: "R. L. Stevenson, author of *Dr. Jekyll and Mr. Hyde* and *Treasure Island,* wrote a short story called 'Suicide Club,' set in Victorian London, where every night people who do not dare to commit suicide, but who wish to die, go to play a card game. The club owner deals cards from a deck one by one, and the player who is dealt A♣ has to kill the player who is dealt A♠. I found the short story so exciting that I made a game of it."

OPPOSITE
This colorful deck, called *Cartes Comiques,* is full of character, with richly drawn caricatures of all sorts of people transmogrified as animals. Note the Jack of Hearts as Don Juan.

What makes Suicide fun to play is its reliance on absolute, utter chance—there is no skill involved, just a pure, nail-biting reliance on luck. The game is best with four or more people. You will need a 52-card deck and counters, chips, or (if you're really brave) units of currency to bet with.

No. of players: 4+ Difficulty: easy

GAME TIP
As it's very easy to cheat when playing Suicide, don't play for high stakes or with people you don't know well.

AIM

To not be dealt the Ace of Spades.

DEALING

One player shuffles the cards, then passes them to the player to the left. There is no traditional deal as such.

PLAY

All players put some money into the pot (*anteing in*) before play begins. The first player cuts the deck (takes the top half of the cards and places them under the other half) and then

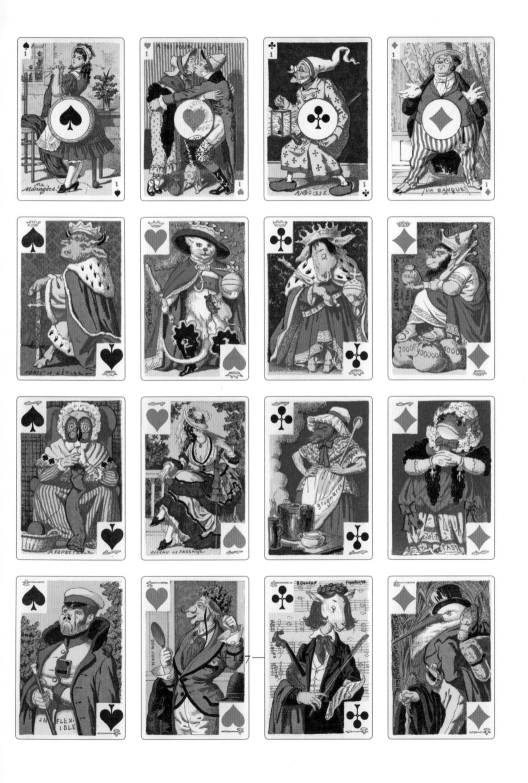

takes at least one card (you may take more, which is ill-advised but can be thrilling).

The drawn cards are turned over immediately. If a player gets the A♠ they are out of the game, must shuffle the deck again, and pass it to the left. If a player draws any other card, they simply push the deck to the left for the next player to draw.

Play continues until a player turns over the A♠, at which point they are out of the game and the whole deck must be shuffled again. The game continues until all but one player, the winner of the pot, is left.

The players who have left the game may, if they choose, lay side bets on which of the remaining players will be next to draw the A♠.

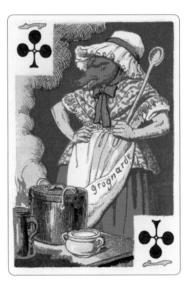

The queen of clubs is a frightening-looking cook, bringing to mind the pepper-obsessed Duchess's cook in Lewis Carroll's *Alice's Adventures in Wonderland*.

HEARTS

Hearts can be played with four to eight people, though the game is best played by even numbers. You'll need a standard 52-card deck to play, and Aces are high.

No. of players: 4–8 Difficulty: medium

GAME TIP
After the first *trick*, players are permitted to lead with Spades— try intentionally leading with low Spades to force the Queen to be revealed. This is called *smoking out the Queen.*

AIM

Avoid scoring points by trying not to win tricks (rounds of the game) containing cards that score points—namely any Heart card or the Q♠, called the *Black Maria.*

DEALING

The dealer deals out cards one at a time so that players all have the same number of cards—if playing with an odd number of people, once everyone's been dealt the same number of cards you might have some leftovers, or *hole* cards. Pick these up without looking at them and put them to one side—they can be shuffled back into the deck on the next deal.

BASIC HEARTS

The player to the left of the dealer leads first, putting down the first card in the trick—which can be any card but a Heart. One by one, players must *follow suit* (put down any card of the same suit led), or if they cannot, put down a card of any suit. There is an exception to the leading card being able to be anything but a Heart—once Hearts have been *broken,* i.e., a player couldn't follow the suit of a lead card and played

a Heart instead. After Hearts have been broken, you may lead with a Heart card.

Once all players have put down a card, the highest-ranking card of the same suit of the card that led the trick wins, and the player who played that card takes all the cards in the trick and puts them face down in a pile in front of themselves until the end of the hand. Remember, the aim of the game is to keep your score low by avoiding taking tricks, so try to avoid playing the highest-ranking card.

The winner of the trick leads the first card for the next trick, and scores are totaled up at the end of each hand, with Hearts being one point and the Queen of Spades being thirteen points.

SHOOTING THE MOON

If a player manages to collect all thirteen Hearts and the Queen of Spades in one hand, they receive a score of zero, while all other players receive 26 points. It's a big risk, because if one of the other players gets a point card, their score will be high, so think it through before acting rashly!

PASSING

If you have an even number of players, passing is a great addition to the game. After the first deal, every player picks three cards they want to get rid of and passes them face down to the person on their left. After the second deal, every player passes their three cards to the player on their right. After the third deal every player passes three cards to the player opposite. At the fourth deal no cards are passed, and then the passing goes back to passing to the left. As you don't want to win tricks, it's a good idea to get rid of your highest-ranking cards by passing them.

GAME OVER
Play goes on until one player reaches 100 points, which signals the end of the game—whichever player has the lowest score is the winner.

NLK

NLK is a Hungarian game good for groups of four and more, popularly played by students at Szeged University. Its name is a little rude, with the N standing for *nagy* meaning *big*, L standing for any nationality that's name begins with the letter L, for example, *Lithuanian*, and K standing for *kibaszós*, or *screw*.

The amount of cards used varies as follows depending upon how many are in your party:

- Four players: a 32-card deck, with the Ace as the highest card and 7 as the lowest card
- Five players: a 36-card deck, with the Ace as the highest card and 6 as the lowest card
- Six players: a 40-card deck, with the Ace as the highest card and 5 as the lowest card

This goes on in the same way until there are nine players or more who use a full standard 52-card deck with the Ace as the highest card.

No. of players: 4+ **Difficulty:** challenging

AIM

The game's hands have two phases. In the first phase players stockpile cards, and in the second phase they try to lose them. At the end of phase two, the loser is the last player who still has cards.

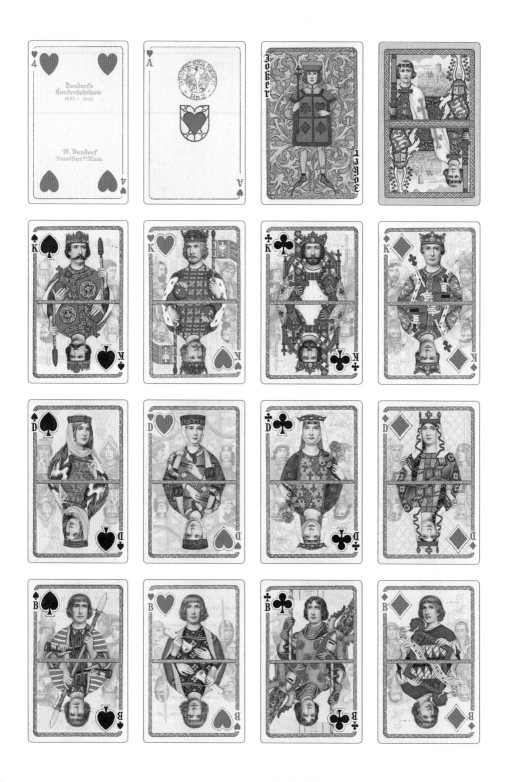

DEALING

One card is dealt face up to every player—this card will become the base of a pile of cards which in phase two will become the player's hand. The rest of the cards are placed face down to become the *talon* (the stockpile).

PLAY

At the start of a player's turn, they may (if they wish to) move the top card from their stack onto the top of another player's stack, provided that the move is a *legal* one. You may place a card on another player's stack as long as it is one higher than the card it's being placed on, regardless of what the suits are—e.g., a 7 can be placed on an 8. The lowest ranking card in the game may also be placed on an Ace, e.g., in a five-player game, the 6 can be placed on it. When a player has gotten rid of their top card, if the one below could be placed on top of another stack, they may place this too, and keep placing cards as long as the moves are legal.

Similarly, if a player draws the top card from the talon and it fits on another player's stack, they may place it there rather than on their own stack. If a player does this, they must draw another card from the talon, but if it would be a legal move, they may also give this card to another player.

Once a player draws a card that they place on their own stack, either because they can't get rid of it or because they choose to keep it, it is the end of their turn. Giving away cards is optional—you may keep your talon card if you like.

Once a player has taken the last card from the stockpile, phase one has ended. The suit of the last card drawn determines the *trump* suit (the suit that outranks all other suits) for phase two, all players pick up their cards, and the player who drew the card leads the first trick.

OPPOSITE
This *Hundertjahrkarte* deck was created by Dondorf to celebrate their 100th anniversary in 1933. The medieval-style illustrations are beautifully intricate, front and back; note the attendants standing behind each character. The power and virtue of the German character is being emphasized in this deck.

Next, players try to get rid of the cards they have collected. The first player may lead with any card, and the next player then tries to beat it by either putting down a higher card of the suit led or a trump card. If a player is unable to or doesn't want to beat the previous card, they must pick up the lowest card in the trick and add it to their hand—this is the lowest card of the suit led, or if there are only trumps, then the lowest trump card. Then the next player puts down a card to try and beat the last card played, and so on. The trick comes to an end when it is either *full* or *empty*:

1. The trick is full when the number of cards played to the trick is equal to the number of players who were still in play when the card was led. The cards in the trick are put to one side and the player who played last and highest to the trick begins the next by leading with any card.
2. The trick is empty when a player picks up the last remaining card in the trick instead of playing it. The turn to lead any card then passes to the next player.

You're never obligated to play to a trick unless it's your turn to lead the trick—you may always pick up the lowest card instead. So some rounds may go a few times around the group before they are finished, and it might happen that you play to the same trick more than once.

Players are out of the game once they run out of cards, which cuts down the number played in future tricks. If a player won a previous trick with their last card, and is due to lead the next trick but now can't, the turn passes to the next player. When only one person has cards left, the game is over, and that person is the loser. In the case that there are two players left, with one card each, the player who leads their card is the winner even if the next person's card beats the led card.

SCATTERBRAIN

Scatterbrain uses a standard deck of 52 cards.

No. of players: 4 Difficulty: challenging

INVENTED BY
Rob Dufour
hypnoguy81@yahoo.ca

AIM
Be the first player to score 100 points.

DEALING
The dealer deals each player seven cards face up so everyone can see them. The players then pick up their cards and decide on one *hole* card. This is placed face down in front of them. The dealer then flips over a card from the remaining deck which will start the discard pile.

PLAY
Collecting a straight: Players must first try to collect a straight using all seven of their cards (including the hole card). The suit does not matter. Players take turns picking up a card from the deck or the discard pile. They then choose one of their cards to place face up on the discard pile. All cards on the discard pile must be able to be seen. The hole card cannot be discarded or swapped, and it must remain on the table at all times. The first player to collect a straight must show his hand and say "Scatterbrain." They are awarded ten points. If the straight is *pure* (all red or black) points are doubled, and if it is *top* (all the same suit) points are tripled.

MERCY HAND
If a player has a straight immediately after dealing (a Mercy Hand), they receive points and the same dealer re-deals the cards. Play continues with people trying to score straights.

—155—

Guessing cards: When play passes to a person who has already scored a straight, they can guess a card that is not face up on the table for points. For example: Player A has already scored a straight. If there is no 5♦ face up on the table, Player A can say "five of Diamonds." If Player B has the 5♦ they must give Player A the card, which is placed face up on the table. Player A receives two points and Player B must pick up another card. If the 5♦ was Player B's hole card, Player B must give Player A his whole hand, with the hole card facing up. Player A receives twenty points, and Player B is then out of the hand. If no one has the named card, play continues as normal until all cards have been used.

If the deck ends before anyone scores a straight, the next player can guess a card. If that is someone's hole card, the player receives twenty points. If it is in someone's hand, the card is discarded and the next player can guess a card. The hand is over when a player correctly guesses a hole card.

If the deck ends after at least one person has a straight, the next person with a straight can guess a card. If that is someone's hole card, the player receives twenty points. If it is in someone's hand, the card is discarded and the next player with a straight can guess a card. The hand is over when a player correctly guesses a hole card.

SCORING

- Completing a straight: ten points
- Pure straight (all red or black): twenty points
- Top straight (all the same suit): thirty points
- Guessing a card in hand: two points
- Guessing a hole card: twenty points

OPPOSITE
Handmade by Simon Wintle, this Spanish-suited pack of playing cards mimics sixteenth-century French and Spanish production, and is based upon surviving specimens. This pattern, now completely extinct today, has been brought back to life with lively colors and arresting figures.

GAME OVER
Deals are played until a player has 100 points (or more) at the end of a hand. In a tie situation, all players continue to play hands until there is a single winner.

INDEX

ACKNOWLEDGMENTS

Many thanks are owed to the following people:

For their help in sourcing images: Simon Wintle, curator of the wonderful card website www.wopc.co.uk; Barney Townshen, card collector; and the English Playing Card Society for the beautiful decks. The game inventors—thanks for your creative genius and for sharing your games with the world: David Parlett, Gábor Légrády, György Kápolnás, Steve Bradbury, Andrew Brewood, Francis Irving, Nic Giacchino, Joakim Malmquist, and Rob Dufour. For being the best card-game site out there: www.pagat.com. Finally, huge thanks to the editorial and design dream team at Ilex Press who put this book together so beautifully, and to Benjamin Potter for playing many, many games of cards with me.

PICTURE CREDITS

p2, 99 Woodblock deck, © Simon Wintle, 2011; p4, 136 *Feine Bergmannskarte*, © Industrie Comptoir, 1816; p6 The Popish Plot deck, © The Trustees of the British Museum, 1679; p9, 81, 129 The Paris Pattern deck, © B. P. Grimaud, c. 1855; p14–15, 39 *Stuart Zeit* deck, © B. Dondorf, c. 1895; p19 Anti-Perón deck, © Anonymous, c. 1998; p20–21 Empire No. 170 deck, © B. Dondorf, c. 1894; p23 *Haupstadte-Spiel* deck, © B. Dondorf, c. 1910; p27, 40 *Islenzk Spil* deck, © Magnus Kjaran, c. 1930; p33, 77, 131 *Shakespeare-Spielkarte*, © B. Dondorf, c. 1906; p36–37 *Luxus Club Karte No.184*, © B. Dondorf, c. 1900; p50–51, 56, 82, 106 Ibero-American deck, © Viuda e Hijos de Heraclio Fournier, 1929; p58 *Mittelalter No.150*, © B. Dondorf, 1889; p61–62 *Tarot Microscopique* deck, © B. Dondorf, c. 1870; p72–73 *Kinder-Karte*, © B. Dondorf, c. 1870; p87, 91 *Baronesse Whist No.106*, © Dondorf GmbH, c. 1900; p92, 95 Whist No.80, © Dondorf GmbH, c. 1928; p98, 122–123 Transformation deck, © The Trustees of the British Museum, 1877; p111, 113 New Style deck, © Soviet Playing Card Monopoly, 1930; p116–117, 119 *Vier-Erdteile* deck, © B. Dondorf, c. 1870; p137, 142 *Club Karte*, © B. Dondorf, c. 1860; p138 Cocktail deck, © Häusermann, c. 1925; p144–145 Satirical deck, © The Trustees of the British Museum, 1720; p147–148 *Cartes Comiques*, © B. Dondorf, 1870; p152 *Hundertjahrkarte*, © B. Dondorf, 1933; p156 Spanish deck, © Simon Wintle, 2011

Häusermann and Dondorf images courtesy Barney Townsend; *Feine Bergmannskarte* images courtesy Klaus-Jürgen Schultz; all other images courtesy Simon Wintle. Every effort has been made to clear copyright and credit the images correctly, however the publisher apologizes for any unintentional omissions.